Norman Rockwell
Collectibles
Value Guide

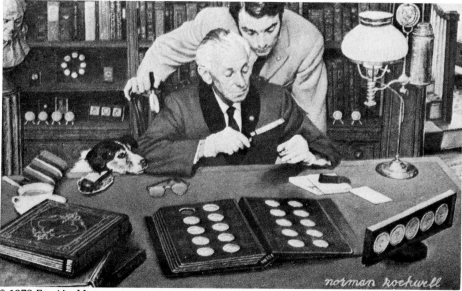

© 1973 Franklin Mint

The Little Rockwell Book

Created by Mary Moline

for

RUMBLESEAT PRESS, INC.
San Francisco, California 94123

Oh Gosh! Wha'Tuv I Done?

Second Edition

COPYRIGHT © 1979 by Rumbleseat Press, Inc.

Library of Congress Catalog Card Number — 79-64761
ISBN 0-913-444-04-9

Manufactured in U.S.A.

First Printing . . . May, 1978
Second Printing . . . October, 1978
Second Edition . . . June, 1979

ACKNOWLEDGEMENTS

We are sincerely grateful and wish to acknowledge the generous contribution of information and photographs supplied by:

The Continental Mint
Rye, New York 10580

Brantwood - Trines
201 West First Street
Dixon, Illinois 61021

Anchor Hocking
109 North Broad Street
Lancaster, Ohio 43130

The Bradford Exchange
8700 Waukegan Road
Morton Grove, Illinois 60053

Boy Scouts of America
New Brunswick, New Jersey 08903

Brown & Bigelow
450 North Syndicate Street
Saint Paul, Minnesota 55104

Creative World
39 Westmoreland
White Plains, New York 10606

Donald Art Company
90 South Ridge Street
Port Chester, New York 10573

Circle Gallery Ltd.
108 South Michigan
Chicago, Illinois 60603

CPS Industries
Columbia Highway
Franklin, Tennessee 37064

Craft House Corporation
2101 Auburn Avenue
Toledo, Ohio 43696

Eleanor Ettinger, Inc.
305 East 47 Street
New York, New York 10017

The Franklin Mint
Franklin Center, Pennsylvania 19091

Gorham Division of Textron
333 Adelaide Avenue
Providence, Rhode Island 02907

Great Lakes Press
439 Central Avenue
Rochester, New York 14605

Dave Grossman Designs, Inc.
2383 Chaffee Drive
Saint Louis, Missouri 63141

Haddad's Fine Art
3855 Mira Loma Avenue
Anaheim, California 92803

The Hamilton Mint
210 North Main
Jacksonville, Florida 32202

Harrison Fisher Society
230 Cedar Street
Minocqua, Wisconsin 54848

Joy's Limited Editions
852 Seton Court
Wheeling, Illinois 60090

Hallmark Greeting Cards
25th and McGee Street
Kansas City, Missouri 64108

Jaymar Specialty Company
200 5th Avenue
New York, New York 10010

R. R. Donnelley & Sons Company
Palo Alto, California 94304
and
Crawfordsville, Indiana 47933

Norman Rockwell Museum
6th and Walnut Streets
Philadelphia, Pennsylvania 19103

The Old Corner House
Stockbridge, Massachusetts 01262

Parker Brothers, Inc.
P. O. Box 900
Salem, Massachusetts 01970

Rockwell Society of America
3 Gables Avenue
Long Island, New York 11733

Rockwell Museum
6677 North Lincoln Avenue
Lincolnwood, Illinois 60645

River Shore, Ltd.
10185 River Shore Drive
Caledonia, Michigan 49316

Sales Aides International
B5 Benson East
Jenkintown, Pennsylvania 19046

Schmid Brothers Inc.
55 Pacella Park Drive
Randolph, Massachusetts 02368

The Saturdy Evening Post
1100 Waterway Blvd.
Indianapolis, Indiana 46206

SPECIAL CONSULTANTS: Diane Tisch, William S. Gardiner and John R. Low

CONTENTS

Introduction

The purpose of this publication is to provide a service to the inexperienced buyer or seller of Norman Rockwell reproductions, and to serve as a reference guide for the established collector.

The value of each item listed was compiled from information from collectors, dealers and manufacturers throughout the United States. The prices do not always represent the high nor the low of the market. Because the secondary market in Rockwell reproductions is still in its infancy, there is no established guide for the value of some items. The current values listed represent the lastest known exchange value on the secondary market and not on the wholesale level.

The trend at this time is to continue to collect. Few collectors are willing to part with many of their purchases because "Rockwell Collecting" has, in an historical sense, just begun. Mr. Rockwell's death in 1978 boosted the popularity of Rockwell collectibles considerably. Having been involved in this mushrooming Rockwell phenomenon since 1970 it has been gratifying to see the "Value Guide" become an integral part of Rockwell collecting. This second edition has been greatly expanded, and as the market develops, new reproductions, as well as older original collectibles will be added. We have established two new chapters in this edition, added over 100 illustrations, included pricing of magazine covers, illustrations and advertisements, and added ten new manufacturers to our list.

Rumbleseat Press, Incorporated, will endeavor, with each new edition of the **NORMAN ROCKWELL VALUE GUIDE,** to offer the most up-to-date information and illustrations on current and past collectibles. Please help keep us informed by notifying us of unusual discoveries, purchases or sales.

Some people might be offended by the association of Norman Rockwell's paintings with numerous collectibles and reproductions. They need not be. In his autobiography, Mr. Rockwell predestined the course of his own career when he designed his first business card. Note the striking similarity between his card and the contents of this book. The business card, printed in 1911, was described by Mr. Rockwell with the following lofty attributes in his autobiography:

"In the center of it, in bold capitals, was my name: **NORMAN P. ROCKWELL.** *Running down the left side of the card was the following modest description of me and my abilities: Artist, Illustrator, Letterer, Cartoonist; sign painting, Christmas cards, calendars, magazine covers, frontispieces, still life, murals, portraits, layouts, design, etc."*

That business card proved to be prophetic. Rockwell enthusiasts are still discovering previously unknown illustrations and advertisements. Only last month, in Carmel, California, I was overwhelmed and delighted to be casually shown a pastel portrait thought to be a Rockwell. Not only was it a Rockwell, but it established an important link into Rockwell's early life. Inscribed, "To good ole' Clyde, from Norman." It portrays Clyde Forsythe, the friend who encouraged Rockwell to take his work to the *Saturday Evening Post*, instead of wasting his talent attempting to "paint pretty girls."

Each month new Rockwell collectibles are finding their way into the market; and, why not? It should come as no surprise that the work of the man who painted ordinary people in familiar situations is revered by the poor as well as the rich. Not every family can afford an original Rockwell. So, they settle for a reproduction. That the copy is on a plate or a tray does not seem to matter. It is because of this growing industry of reproductions that a detailed documentation of these products is indicated.

Mr. Rockwell's career was well launched at age 22 when his first *Saturday Evening Post* covered appeared. His cover art, for the most part, portrays real people at a moment of common emotional experience. Because he was a most prolific artist. Mr. Rockwell's work appeared in

practically every periodical of his time. An objective appraisal of his work reveals that it is not repetitious, extremely accurate, fresh and ageless.

Some of Mr. Rockwell's work is the most reproduced in the world. While he is the best known and most popular American artist of all time, few of his admirers have seen an original Rockwell. The paradox of Mr. Rockwell's popularity is based on secondhand knowledge of his work through reproduction. That the reproductions have stood the test of time is not surprising. The individual is rare who can say he has not enjoyed looking at Rockwell's work.

His art has been reproduced more often than the combined efforts of Michaelangelo, Rembrant and Picasso. At age 16 he illustrated Christmas cards for Mrs. Arnold Constable; at 17 his first book, at 19 he was art director for Boys' Life magazine. Some of these early illustrations showed little sign of the genius that was to follow. His style in those early years resembled that of a senior contemporary, C.M. Relyea. Fortunately, Mr. Rockwell's style developed into the storytelling pictures we have all grown to recognize and love.

In 1960 Mr. Rockwell was quoted as having said of his work:

"Maybe as I grew up and found the world wasn't the perfectly pleasant place I had thought it to be, I unconsciously decided that if it wasn't an ideal world, it should be and so I painted only the ideal aspects of it."

Therein lies the magic of Norman Rockwell. He painted America, not as it always was, but how he always wanted us to see it. Today, we find Rockwell's influence on most forms of creative work . . . from bells and bowls to figuerines and coins. The Stockbridge Historical Society, the official Norman Rockwell Museum at the Old Corner House in Stockbridge, Massachusetts, houses much of Mr. Rockwell's personal collection. They are in the process of compiling a list of all known original paintings that exists today. If you have an original Rockwell it would be advantageous to register it with the museum in Stockbridge. In return they will verify the paintings authenticity. The "great masters" have been forged. Rockwell's work is certainly not immune.

Mr. Rockwell did not approve of the gross reproduction of his work. His estate receives very little of the financial rewards for the commercialism his art has endured. However, even America's most loved artist could not control his popularity. The public loves Rockwell, Rockwell on anything. Rockwell collecting is a new hobby. Where it will go from here is anybody's guess. But rest assured, that as long as we have spotted dogs, pipe smoking grandpas' and pigtailed girls, he will not be forgotten. Mr. Rockwell provided us a portrayal of the yesterday we want to remember. This guide of facts is a documentation of that incredible achievement.

Mary Moline
San Francisco

To
Steven Lomazow, M.D.
and
William Earle

Rockwell Collectors Extraordinaire

BELLS

Bell collecting is a relatively new hobby; but, this category has established an especially rapid growth pattern. This could perhaps be attributed to the built-in demand created by Rockwell collectors. Generally, collectors tend to want one of each item produced, especially if an illustration is particularly appealing. For instance, *The Butter Girl* plate was so pleasing that when the same illustration appeared on a bell, and then a tray, those who missed getting a plate wanted a bell and a tray. And those who were fortunate to get the plate also wanted the others.

Collecting bells could be an excellent way to begin a stimulating new hobby because early issues are still available at reasonable prices.

In the future, many new items will appear to tempt the collector. You will not go wrong if you buy what you like . . . first. If it grows in value, you made a wise choice. If it does not increase in value, and many "Rockwells" **do not**, at least you have something you can live with.

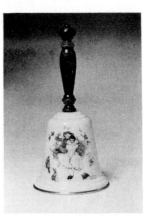

***Sweet Song So Young**

Gorham Fine China

9 inches high, *Loves Harmony* bell

1974 Issue Price $19.50

Current Value $75.00

***Downhill Daring** Bell

Lincoln Mint

9½ inches high

Hallmarked and Registered

1975 Issue Price $25.00

Current Value $50.00

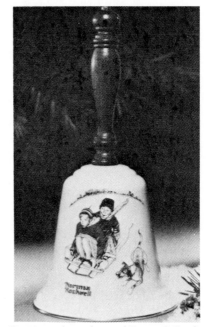

Doctor and Doll

The Danbury Mint, Series I

Number 1 bell, 7 inches high

1975 Issue Price $27.50

Current Value $50.00

**Art from the archives of Brown & Bigelow*

BELLS

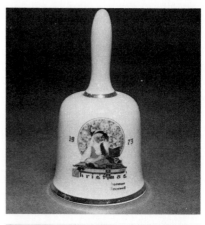

Faces of Christmas Bell

Dave Grossman Designs, Inc.

9,500 Limited Edition

(*S.E.P.* 12/4/20)

1975 Issue Price $12.50

Current Value $18.00

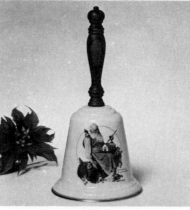

Santa's Helpers Bell

Gorham Fine China

Walnut handle and silver plated clapper

8¾ inches high

1975 Issue Price $15.00

Current Value $35.00

***Love's Harmony** Bell

Gorham Fine China

1½ inches high

Porcelain china with wood handle

1975 Issue Price $19.50

Current Value $45.00

BELLS

Ben Franklin Bicentennial Bell

Dave Grossman Designs, Inc.

10,000 Limited Edition

(*S.E.P.* 5/29/26)

1976 Issue Price $12.50

Current Value $ 17.00

Young Love Bell

Gorham Fine China

9 inches high

1976 Issue Price $19.50

Current Value $ 34.00

*** Snow Sculpture** Bell

Gorham Fine China

10½ inches high with walnut handle

1976 Issue Price $19.50

Current Value $ 42.00

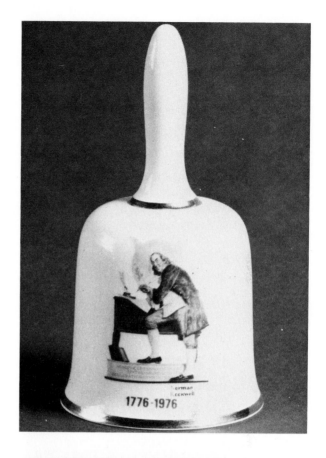

BELLS

Tavern Sign Painter Bell

Gorham Fine China

9 inches high

Walnut handle and silver plated clapper

1976 Issue Price $19.50

Current Value $40.00

Drum For Tommy Bell

Dave Grossman Designs, Inc.

COUNTRY GENTLEMAN. (12-17-21)

1976 Issue Price $12.00

Current Value $15.00

Butter Girl Bell

Royal Devon

6½ inches high

1976 Issue Price $15.00

Current Value $28.00

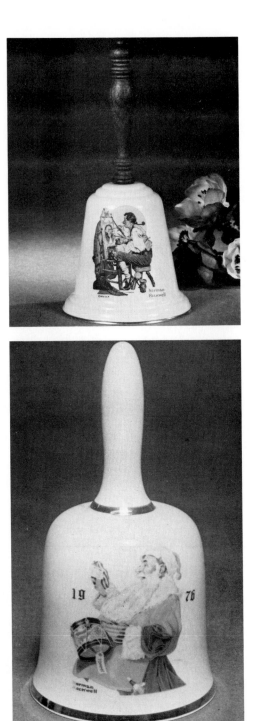

BELLS

*** Chilling Chore** Bell

Gorham Fine China

10½ inches high, walnut handle

1977 Issue Price $19.50

Current Value $45.00

***Fondly Do We Remember** Bell

Gorham Fine China

10½ inches high, walnut handle

1977 Issue Price $19.50

Current Value $32.00

The Children Series

River Shore, Ltd., Bell Series No. 1

Set of four with showcase

1977 Issue Price $30.00 each bell

1977 Issue Price $120.00 per set of four

Current Value $180.00

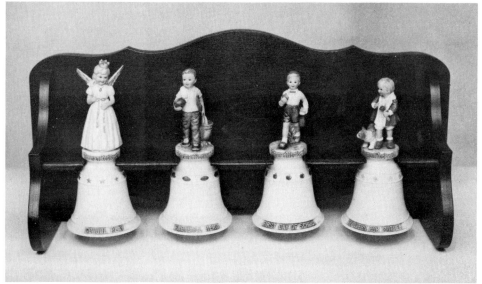

© 1977 River Shore, Ltd.

BELLS

Grandpa Snowman

The Danbury Mint, Series I

Number 2 bell, 7 inches high

1976 Issue Price $27.50

Current Value $40.00

Freedom From Want

The Danbury Mint, Series I

Number 3 bell, 7 inches high

1976 Issue Price $27.50

Current Value $40.00

No Swimming

The Danbury Mint, Series I

Number 4 bell, 7 inches high

1976 Issue price $27.50

Current Value $40.00

Saying Grace

The Danbury Mint, Series I

Number 5 bell, 7 inches high

1976 Issue price $27.50

Current Value $40.00

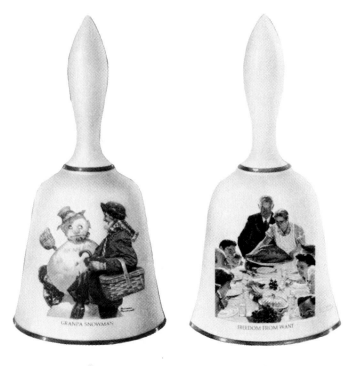

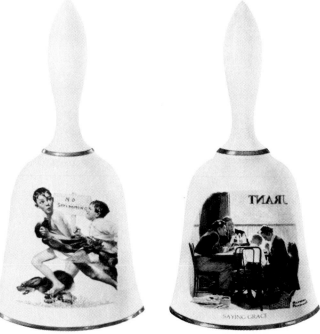

BELLS

The Discovery

The Danbury Mint, Series I

Number 6 bell, 7 inches high

1976 Issue Price $27.50

Current Value $40.00

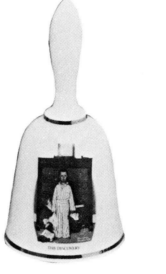

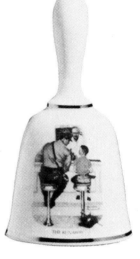

The Runaway

The Danbury Mint, Series I

Number 7 bell, 7 inches high

1977 Issue Price $27.50

Current Value $40.00

Knuckles Down

The Danbury Mint, Series I

Number 8 bell, 7 inches high

1977 Issue Price $27.50

Current Value $40.00

Tom Sawyer

The Danbury Mint, Series I

Number 9 bell, 7 inches high

1977 Issue price $27.50

Current Value $40.00

BELLS

Puppy Love

The Danbury Mint, Series I

Number 10 bell, 7 inches high

1977 Issue Price $27.50

Current Value $40.00

Santa's Mail

The Danbury Mint, Series I

Number 11 bell, 7 inches high

1977 Issue Price $27.50

Current Value $40.00

The Remedy

The Danbury Mint, Series I

Number 12 bell, 7 inches high

1977 Issue Price $27.50

Current Value $40.00

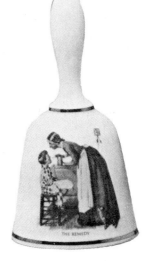

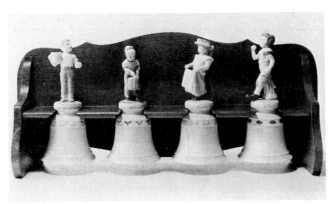

The Children Series

River Shore, Ltd., Bell Series No. 2

15,000 sets of four

1978 Issue Price $140.00

Current Value $175.00

© 1978 River Shore, Ltd.

BELLS

***Gaily Sharing Vintage Times** Bell

Gorham Fine China

8½ inches high

1978 Issue Price $19.50
Current Value $20.00

***Gay Blades** Christmas Bell

Gorham Fine China

8½ inches high

1978 Issue Price $22.50

Current Value $24.00

Triple Self-Portrait

The Norman Rockwell Commemorative Bell

The Danbury Mint

7 9/16" limited edition

1979 Issue Price $27.50

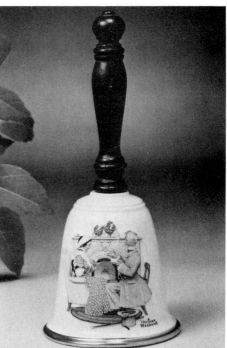

**Art from the archives of Brown & Bigelow*

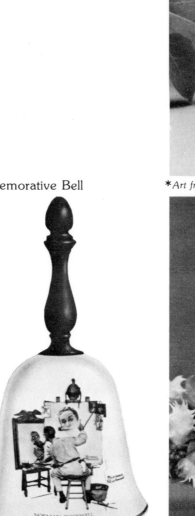

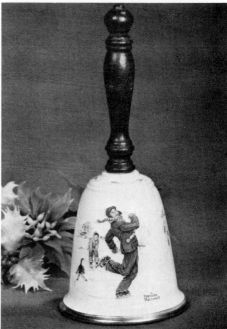

BELLS

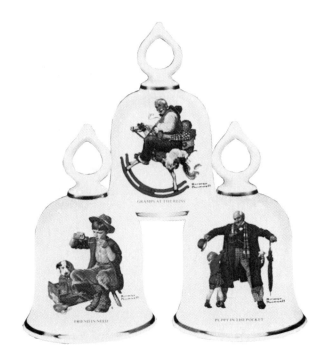

Gramps At The Reins

The Danbury Mint Series,

The Wonderful World of Norman Rockwell

5 3/8 inches high (*S.E.P.* 12-10-33)

1979 Issue Price $27.50

Friend In Need

The Danbury Mint Series,

The Wonderful World of Norman Rockwell

5 3/8 inches high (*S.E.P.* 3-10-23)

1979 Issue Price $27.50

Puppy In The Pocket

The Danbury Mint Series,

The Wonderful World of Norman Rockwell

5 3/8 inches high (*S.E.P.* 1-25-36)

1979 Issue Price $27.50

BELLS

Grandpa's Girl

The Danbury Mint Series,

The Wonderful World of Norman Rockwell

5 3/8 inches high (*S.E.P.* 2-3-23)

1979 Issue Price $27.50

Leapfrog

The Danbury Mint Series,

The Wonderful World of Norman Rockwell

5 3/8 inches high (*S.E.P.* 6-28-19)

1979 Issue Price $27.50

Baby-Sitter

The Danbury Mint Series,

The Wonderful World of Norman Rockwell

5 3/8 inches high (*S.E.P.* 5-20-16)

1979 Issue Price $27.50

Batter-Up

The Danbury Mint Series,

The Wonderful World of Norman Rockwell

5 3/8 inches high (*S.E.P.* 8-5-16)

1979 Issue price $27.50

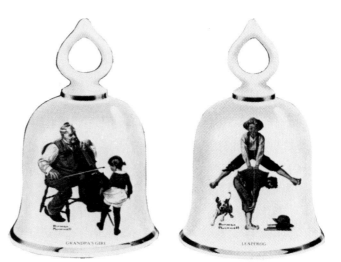

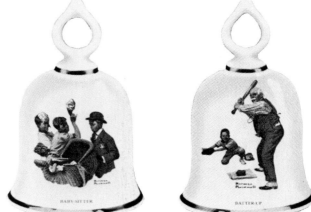

BELLS

Back to School

The Danbury Mint Series,

The Wonderful World of Norman Rockwell

5 3/8 inches high (*S.E.P.* 9-14-35)

1979 Issue Price $27.50

∗A Boy Meets His Dog

Gorham Fine China, Christmas Bell

8½ inches high, limited edition

1979 Issue price $24.50

∗Beguiling Buttercup

Gorham Fine China, *Loves Harmony* Bell

8½ inches high, limited edition

1979 Issue Price $24.50

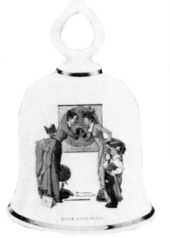
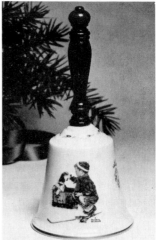
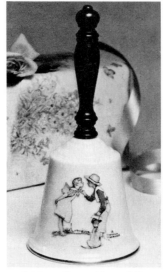

∗Art from the archives of Brown & Bigelow

FIGURINES

Mr. Rockwell's art is characterized by its life-like quality. The figurine is the only collector medium that affords a three dimensional portrayal of his work.

A series of seventeen Rockwell inspired figurines and one display placque were produced and exported to the United States by Goebel Hummelwerk in West Germany. They were distributed exclusively by Ebeling and Reuss, Devon, Pennsylvania. The entire stock was sold by them by mid-1966.

The secondary market in figurines is comparatively slow-paced; however, trading is slowly but steadily increasing. The reasons for this slow development has been that historically, figurine collectors are just that, collectors. Also, few suppliers produce figurines, and limited editions once were truly — limited; thus, the demand for Gorham and Grossman figurines is far greater than the supply.

1963

* **Little Veterinarian** Rock 201

Goebel Hummelwerk by Skrobek

6 inches high, 500 pieces

1963 Issue Price $15.00

1978 Value $50.00

Current Value $270.00

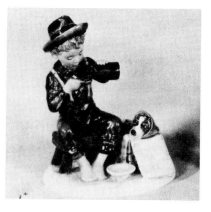

**Art from the archives of Brown & Bigelow*

* **Boyhood Dreams** Rock 202

Goebel Hummelwerk by Muller

4 inches x 6 inches high, 500 pieces

1963 Issue Price $12.00

1978 Value $30.00

Current Value $250.00

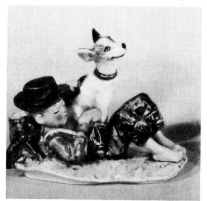

FIGURINES

*** Mother's Helper** Rock 203

Goebel Hummelwerk by Muller

5½ inches high, 500 pieces

1963 Issue Price $15.00

1978 Value $30.00

Current Value $250.00

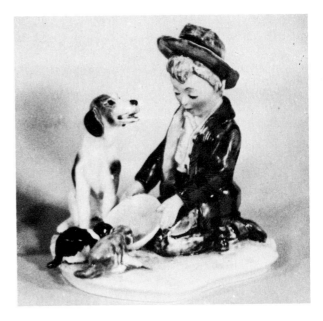

***His First Smoke** Rock 208

Goebel Hummelwerk by Menzenback

4½ inches high, 500 pieces

1963 Issue Price $9.00

1978 Value $25.00

Current Value $250.00

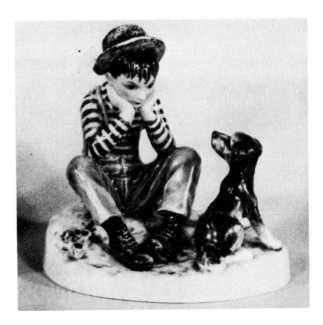

FIGURINES

***My New Pal** Rock 204

Goebel Hummelwerk by Skrobek

5 inches high, 500 pieces

1963 Issue Price $12.00

1978 Value $30.00

Current Value $250.00

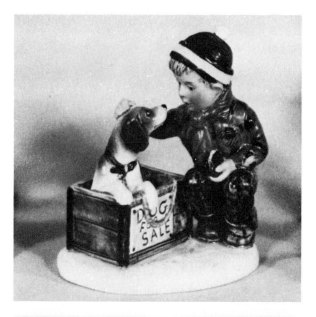

***Home Cure** Rock 211

Goebel Hummelwerk by Bochmann

6 inches by 6½ inches, 500 pieces

1963 Issue Price $16.00

1978 Value $35.00

Current Value $250.00

* Art from the archives of Brown & Bigelow

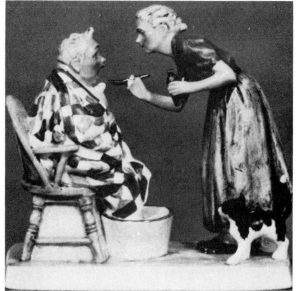

FIGURINES

***Timely Assistance** Rock 212

Goebel Hummelwerk by Bochmann

6 inches high, 500 pieces

1963 Issue Price $16.00

1978 Value $35.00

Current Value $250.00

***She Loves Me** Rock 213

Goebel Hummelwerk by Bochmann

4 inches high, 500 pieces

1963 Issue Price $8.00

1978 Value $25.00

Current Value $250.00

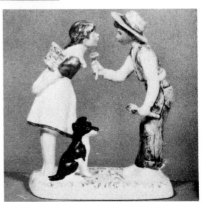

***Buttercup Test** Rock 214

Goebel Hummelwerk by Bochmann

5 inches high, 500 pieces

1963 Issue Price $10.00

1978 Value $32.00

Current Value $250.00

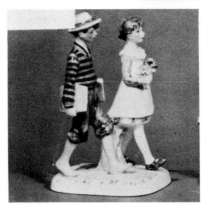

***First Love** Rock 215

Goebel Hummelwerk by Bochmann

5½ inches high, 500 pieces

1963 Issue Price $10.00

1978 Value $30.00

Current Value $250.00

FIGURINES

***Canine Solo** Rock 216

Goebel Hummelwerk by Bochmann

5 inches by 6¼ inches, 500 pieces

1963 Issue Price $16.00

1978 Value $35.00

Current Value $250.00

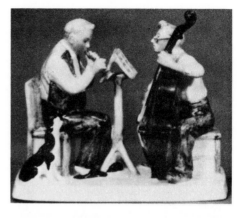

***Patient Anglers** Rock 217

Goebel Hummelwerk by Bochmann

4½ inches x 5½ inches, 500 pieces

1963 Issue Price $18.00

1978 Value $35.00

Current Value $250.00

Advertising Plaque — Rock 218

Goebel Hummelwerk by Bochmann

3 inches x 6 inches, number made unavailable

1963 Issue Price — item used for adv. only

1978 Value $75.00

Current Value $450.00

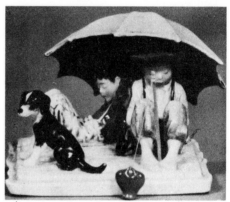

Art from the archives of Brown & Bigelow

Items Rock 205, 206, 207, 209, 210 were numbered
samples but never produced for resale.

FIGURINES

Boy And His Dog Four Seasons Series No. 1 **1972**

Gorham Fine China

* **Adventurers Between Adventures**

* **The Mysterious Malady**

* **Pride of Parenthood**

* **A Boy Meets His Dog**

 1972 Issue Price $200.00 Per Set

 Current Value $1,500.00

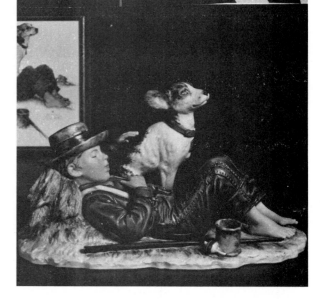

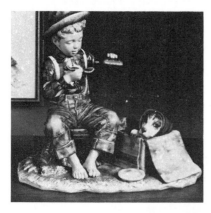

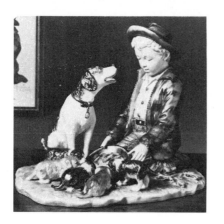

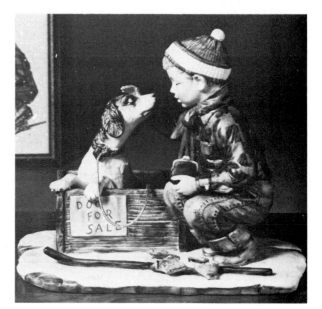

FIGURINES

Boy And His Girl Four Seasons Series No. 2 **1973**

Gorham Fine China

***Beguiling Buttercup**

***Flying High**

***A Scholarly Pace**

***Downhill Daring**

1973 Issue Price $250.00 Per Set

Current Value $1,000.00

* *Art from the archives of Brown & Bigelow*

FIGURINES

Four Ages Of Love Four Seasons Series No. 3 **1974**

Gorham Fine China

*Sweet Song So Young

*Flowers In Tender Bloom

*Fondly Do We Remember

*Gaily Sharing Vintage Times

1974 Issue Price $300.00 Per Set

Current Value $1,150.00

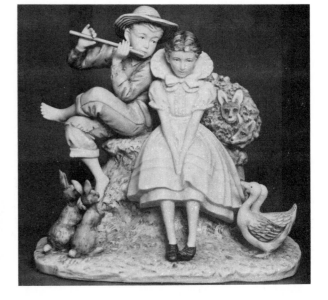

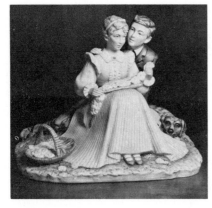

FIGURINES

Grandpa And Me Four Seasons Series No. 4 **1975**

Gorham Fine China, Ltd. Ed. 2,500 Sets of Four

***Day Dreamers**

***Goin' Fishin'**

***Pensive Pals**

***Gay Blades**

1975 Issue Price $300.00 Per Set

Current Value $850.00

* *Art from the archives of Brown & Bigelow*

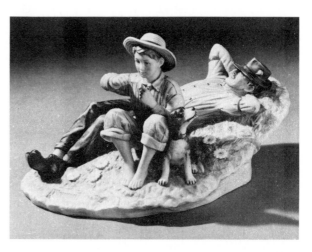

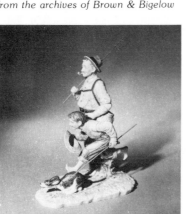

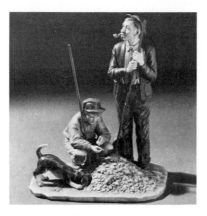

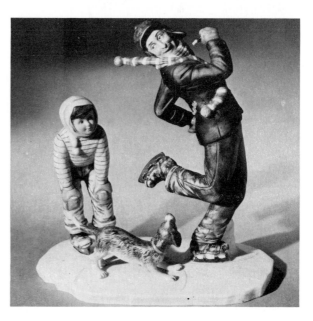

FIGURINES

Me And My Pal Four Seasons Series No. 5 **1976**

Gorham Fine China

Young Man's Fancy

Fisherman's Paradise

Disasterous Daring

A Lickin' Good Bath

1976 Issue Price $300.00 Per Set

Current Value $850.00

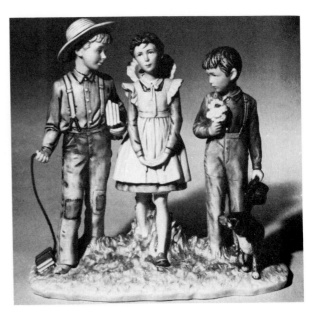

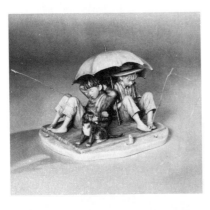

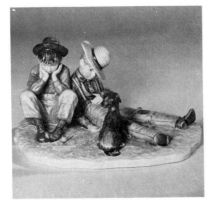

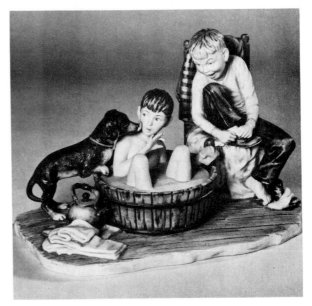

FIGURINES

Grand Pals Four Seasons Series No. 6 **1977**

Gorham Fine China

8½ inches high, Ltd. Ed. 2,500 Sets of Four

***Soaring Spirits**

***Fish Finders**

***Ghostly Gourds**

***Snow Sculpturing**

1977 Issue Price $350.00 Per Set

Current Value $600.00

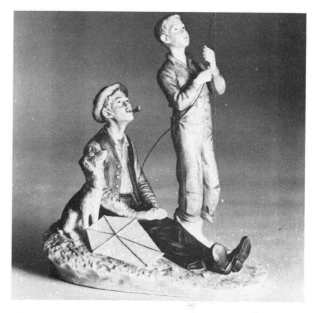

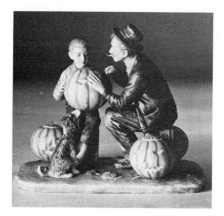

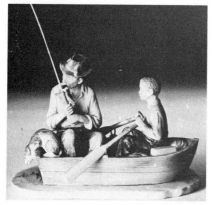

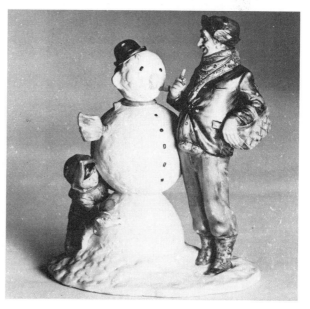

FIGURINES

Going On Sixteen Four Seasons Series No. 7

Gorham Fine China, Sets of Four

*****Shear Agony** Summer

*****Sweet Serenade** Spring

*****Pilgrimage** Fall

*****Chilling Chore** Winter

1978 Issue Price $400.00

Current Value $600.00

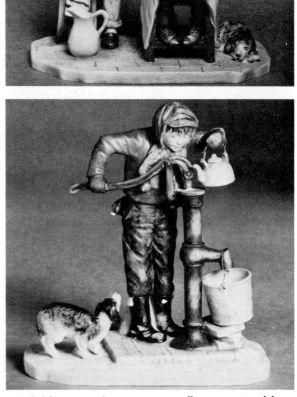

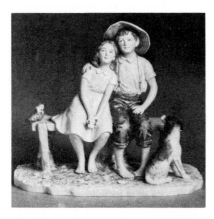

Gorham Fine China figurines were available as single issues as well as in sets of four.

FIGURINES

The Jockey RW-1

Gorham Fine China

June 28, 1958 *S.E.P.* Cover

6¾ inches high

Issue Price $40.00

Current Value $70.00

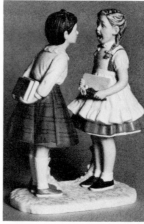

Missing Tooth RW-2

Gorham Fine China

September 7, 1957 *S.E.P.* Cover

6 inches high

Issue Price $30.00

Current Value $60.00

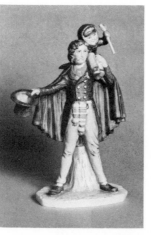

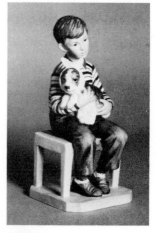

Tiny Tim RW-3

Gorham Fine China

December 15, 1934 *S.E.P.* Cover

6½ inches high

Issue Price $30.00

Current Value $55.00

At The Vets RW-4

Gorham Fine China

March 29, 1952 *S.E.P.* Cover

6 inches high

Issue Price $25.00

Current Value $50.00

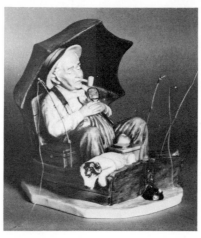

Fishing RW-5

Gorham Fine China

6 inches high

Issue Price $50.00

Current Value $90.00

FIGURINES

Batter Up RW-6

Gorham Fine China

June 8, 1939 *S.E.P.* Cover

6¼ inches high

Issue Price $40.00

Current Value $80.00

Skating RW-7

Gorham Fine China

5¾ inches high

Issue Price $37.50

Current Value $70.00

Captain RW-8

Gorham Fine China

5½ inches high

Issue Price $45.00

Current Value $75.00

Boy And His Dog RW-9

Gorham Fine China

March 10, 1923 *S.E.P.* Cover

5 inches high

Issue Price $37.50

Current Value $70.00

No Swimming RW-10

Gorham Fine China

June 15, 1929 *S.E.P.* Cover

6 inches high

Issue Price $35.00

Current Value $70.00

Old Mill Pond RW-11

Gorham Fine China

5½ inches high

Issue Price $45.00

Current Value $80.00

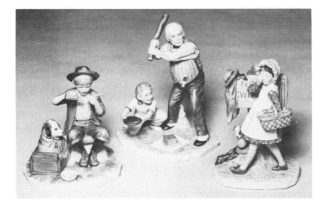

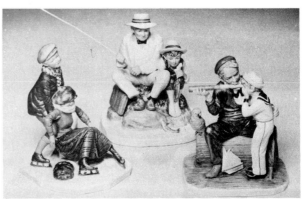

FIGURINES

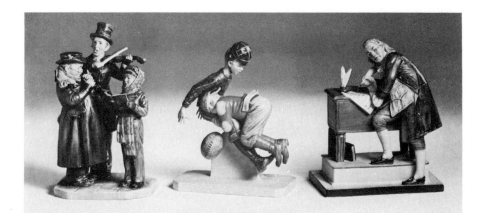

Saying Grace RW-12

Gorham Fine China

November 24, 1951 *S.E.P.* Cover

5½ inches high

Issue Price $75.00

Current Value $120.00

God Rest Ye Merry Gentlemen RW-13

Gorham Fine China

December 8, 1923 *S.E.P.* Cover

7¼ inches high

Issue Price $50.00

Current Value $180.00

Tackled RW-14

Gorham Fine China

November 21, 1925 *S.E.P.* Cover

6½ inches high

Issue Price $35.00

Current Value $70.00

Independence RW-15

Gorham Fine China

May 29, 1926 *S.E.P.* Cover

6½ inches high

Issue Price $40.00

Current Value $70.00

Marriage License RW-16

Gorham Fine China

June 11, 1955 *S.E.P.* Cover

6¼ inches high

Issue Price $50.00

Current Value $85.00

The Occulist RW-17

Gorham Fine China

6¼ inches high

Issue Price $50.00

Current Value $80.00

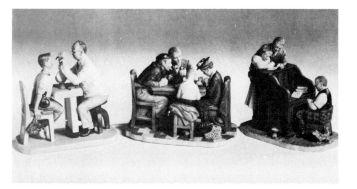

FIGURINES

Pride of Parenthood RW-18

Gorham Fine China

Current Value $80.00

Sweet Song So Young RW-19

Gorham Fine China

Current Value $80.00

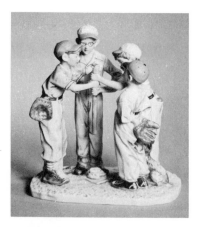

Gaily Sharing Vintage Times RW-20

Gorham Fine China

Current Value $90.00

Gay Blades RW-21

Gorham Fine China

Current Value $80.00

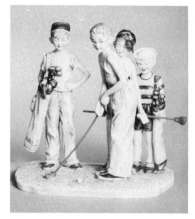

Choosing Up

Gorham Fine China, RW-22

6½ inches high,

Issue Price $105.00

Missed

Gorham Fine China, RW-23

6½ inches high

Issue Price $105.00

Oh Yeah

Gorham Fine China, RW-24

6½ inches high

Issue Price $105.00

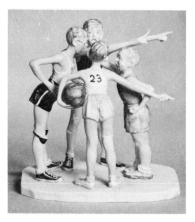

FIGURINES

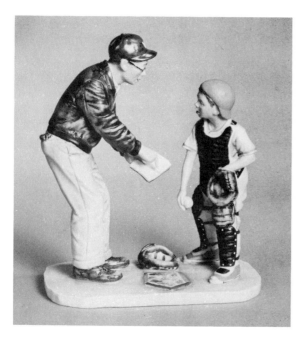

Big Decision

Gorham Fine China, RW-25

6¾" inches high

Issue Price $105.00

Runaway

Gorham Fine China, RW-26

6 inches high

1979 Issue Price $90.00

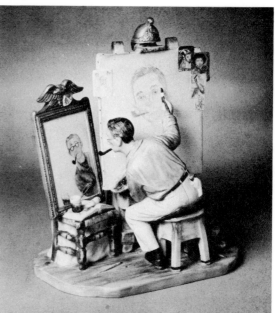

Triple Self-Portrait Memorial Figurine

Gorham Fine China RW-27

7½ inches high (Feb. 13, 1960 *S.E.P.* cover)

1979 Issue Price $125.00

FIGURINES

Redhead NR1

Dave Grossman Designs, Inc.

September 16, 1916 *S.E.P.* Cover

5½ inches high

1973 Issue Price $20.00

1978 Value $24.00 , Retired

Current Value $200.00

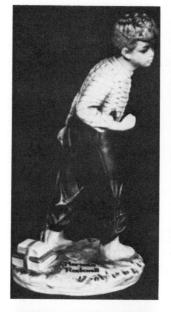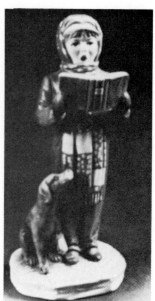

Back to School NR2

Dave Grossman Designs, Inc.

January 8, 1927 *S.E.P.* Cover

6 inches high

1973 Issue Price $20.00

1978 Value $24.00

Current Value $28.00

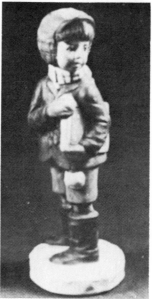

The Carroler NR3

Dave Grossman Designs, Inc.

December 8, 1923 *S.E.P.* Cover

5½ inches high

1973 Issue Price $22.50

1978 Value $27.00

Value Unchanged

FIGURINES

The Daydreamer NR4

Dave Grossman Designs, Inc.

March 6, 1954 *S.E.P.* Cover

5 inches high

1973 Issue Price $22.50

1978 Value $27.00

Current Value $36.00

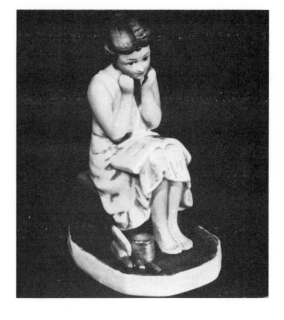

No Swimming NR5

Dave Grossman Designs, Inc.

June 4, 1921 *S.E.P.* Cover

5¼ inches high

1973 Issue Price $25.00

1978 Value $30.00

Current Value $36.00

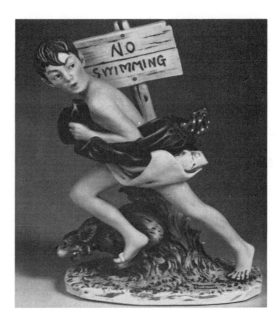

No Swimming NR101

Dave Grossman Designs, Inc.

June 4, 1921 *S.E.P.* Cover

9 inches high, 1000 Ltd. Ed.

1975 Issue Price $150.00

1978 Value $190.00 , Edition Closed

Current Value $300.00

FIGURINES

Love Letter NR6

Dave Grossman Designs, Inc.

January 17, 1920 *S.E.P.* Cover

4½ inches high

1973 Issue Price $25.00

1978 Value $40.00
Current Value $46.00

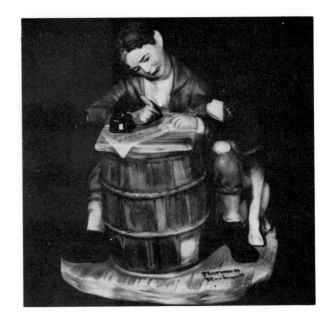

Lovers NR7

Dave Grossman Designs, Inc.

August 30, 1924 *S.E.P.* Cover

5 inches high

1973 Issue Price $45.00

1978 Value $53.00
Current Value $60.00

FIGURINES

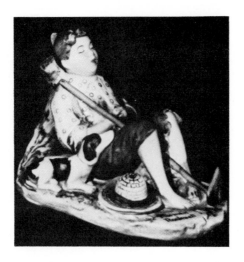

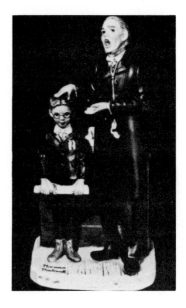

Lazybones NR8

Dave Grossman Designs, Inc.

September 6, 1919 *S.E.P.* Cover

3¼ inches high

1973 Issue Price $30.00

1978 Value $75.00, Retired

Current Value $300.00

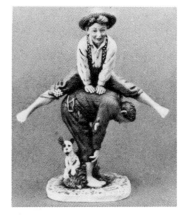

Leapfrog NR9

Dave Grossman Designs, Inc.

June 28, 1919 *S.E.P.* Cover

6¼ inches high

1973 Issue Price $50.00

1978 Value $250.00, Retired

Current Value $375.00

The Schoolmaster NR10

Dave Grossman Designs, Inc.

June 26, 1926 *S.E.P.* Cover

1973 Issue Price $55.00

1978 Value $65.00, Retired

Current Value $100.00

Leapfrog NR-104

Dave Grossman Designs, Inc.

10 inches high, edition of 1000

1979 Issue Price $440.00

FIGURINES

Marble Players NR11

Dave Grossman Designs, Inc.

September 2, 1939 *S.E.P.* Cover

4½ inches high

1973 Issue Price $60.00

1978 Value $125.00, Retired
Current Value $350.00

Doctor and Doll NR100

Dave Grossman Designs, Inc.

March 9, 1929 *S.E.P.* Cover

10¼ inches high, 1000 Ltd. Ed.

1974 Issue Price $300.00

1978 Value $375.00 , Edition Closed
Current Value $500.00

Doctor and Doll NR12

Dave Grossman Designs, Inc.

March 9, 1929 *S.E.P.* Cover

6 inches high

1973 Issue Price $65.00

1978 Value $80.00
Current Value $100.00

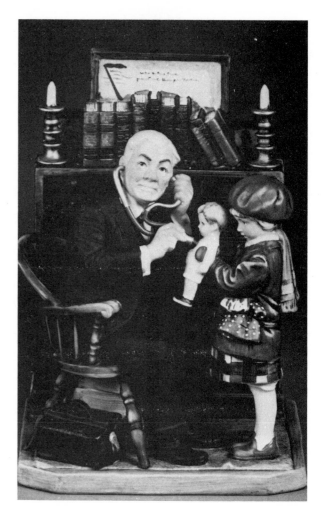

FIGURINES

Friends In Need NR13

Dave Grossman Designs, Inc.

September 28, 1929 *S.E.P.* Cover

5½ inches high

1974 Issue Price $45.00

1978 Value $60.00
Current Value $86.00

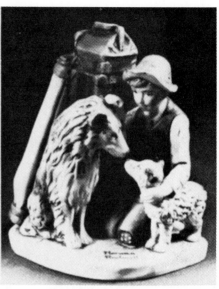

Springtime 1933 NR14

Dave Grossman Designs, Inc.

April 8, 1933 *S.E.P.* Cover

6 inches high

1974 Issue Price $30.00

1978 Value $35.00, Retired

Current Value $44.00

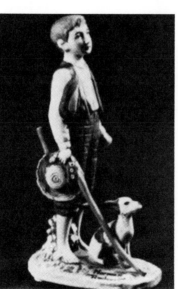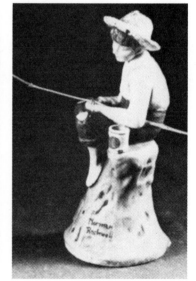

Summertime 1933 NR15

Dave Grossman Designs, Inc.

August 5, 1933 *S.E.P.* Cover

5¾ inches high

1974 Issue Price $25.00

1978 Value $31.00

Current Value $42.00

FIGURINES

Baseball NR102

Dave Grossman Designs, Inc.

July 8, 1939 *S.E.P.* Cover

8 inches high, 1000 Limited Edition

1975 Issue Price $125.00

1978 Value $170.00 , Edition Closed

Current Value $200.00

Baseball NR16

Dave Grossman Designs, Inc.

July 8, 1939 *S.E.P.* Cover

6 inches high

1974 Issue Price $45.00

1978 Value $60.00

Current Value $84.00

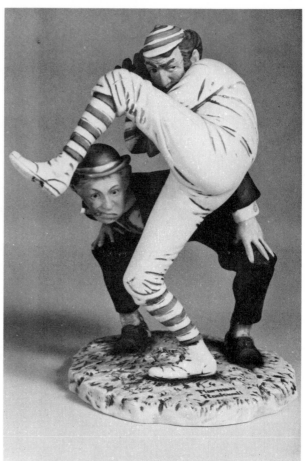

FIGURINES

See America First NR17

Dave Grossman Designs, Inc.

April 23, 1938 *S.E.P.* Cover

6¼ inches high

1974 Issue Price $40.00

1978 Value $47.00

Current Value $58.00

Take Your Medicine NR18

Dave Grossman Designs, Inc.

May 30, 1936 *S.E.P.* Cover

5¼ inches high

1975 Issue Price $50.00

1978 Value $60.00

Current Value $82.00

See America First

Dave Grossman Designs, Inc.

Rare limited edition series of 6 pieces,

largest Rockwell figurine ever produced.

Height 21", never offered for sale.

Estimated current value $10,000

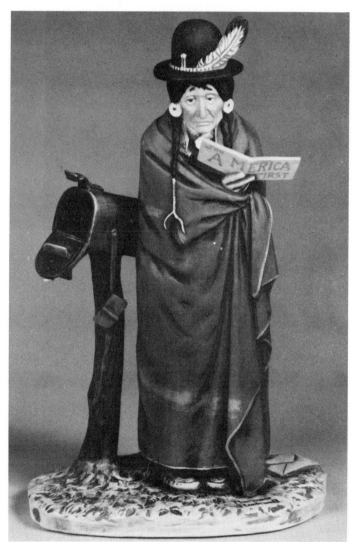

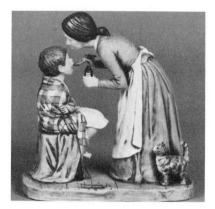

FIGURINES

Springtime 1935 NR19

Dave Grossman Designs, Inc.

April 27, 1935 *S.E.P.* Cover

4¼ inches high

1975 Issue Price $50.00

1978 Value $60.00

Current Value $5,000

Discovery NR20

Dave Grossman Designs, Inc.

December 29, 1956 *S.E.P.* Cover

6 inches high

1975 Issue Price $55.00

1978 Value $65.00

Current Value $82.00

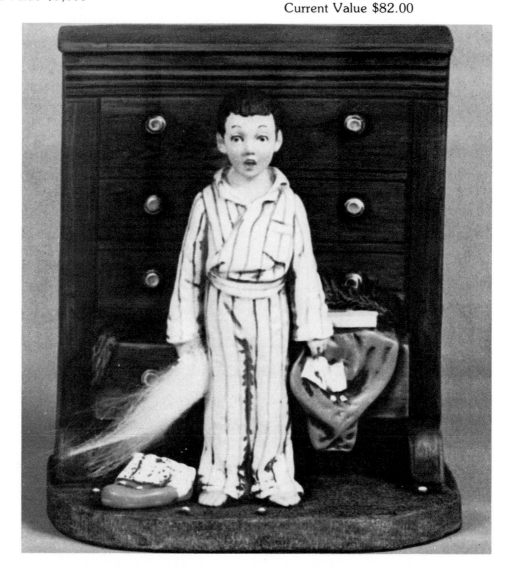

FIGURINES

Barbershop Quartet NR23

Dave Grossman Designs, Inc.

September 26, 1936 *S.E.P.* Cover

7 inches high, 1000 Limited Edition

1975 Issue Price $100.00

1978 Value $135.00

Current Value $175.00

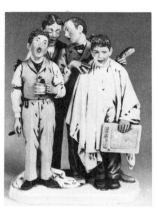

The Circus NR22

Dave Grossman Designs, Inc.

May 18, 1918 *S.E.P.* Cover

5¼ inches high

1975 Issue Price $55.00

1978 Value $65.00

Current Value $80.00

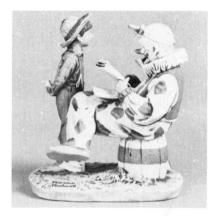

The Big Moment NR21

Dave Grossman Designs, Inc.

January 25, 1936 *S.E.P.* Cover

6½ inches high

1975 Issue Price $60.00

1978 Value $72.00

Current Value $100.00

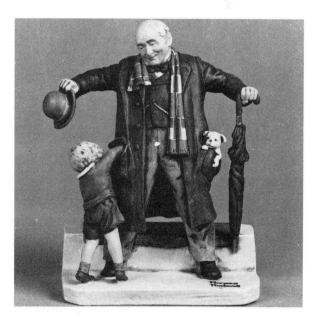

FIGURINES

Drum For Tommy NRC24

Dave Grossman Designs, Inc.

6¾ inches high

1976 Issue Price $40.00

1978 Value $50.00

Current Value $62.00

Pals NR25

Dave Grossman Designs, Inc.

September 27, 1924 *S.E.P.* Cover

5½ inches high

1976 Issue Price $60.00

1978 Value $66.00

Current Value $86.00

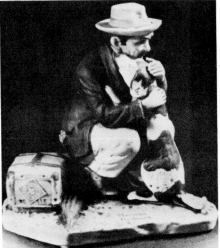

FIGURINES

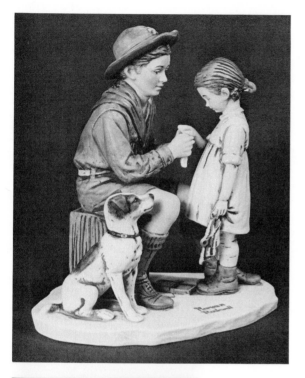

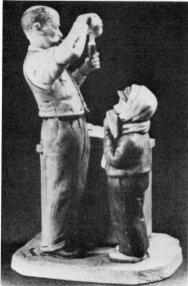

Young Doctor NRD-26

Dave Grossman Designs, Inc.

6 inches high, limited edition

1978 Issue Price $100.00

Current Value $106.00

First Day of School NR-27

Dave Grossman Designs, Inc.

6 inches high (*S.E.P.* 9-14-35)

1978 Issue Price $100.00

Current Value $110.00

Magic Potion NR-28

Dave Grossman Designs, Inc.

6½ inches high (*S.E.P.* 3-19-39)

1978 Issue Price $84.00

Current Value $94.00

At the Doctors NR-29

Dave Grossman Designs, Inc.

5½ inches high (*S.E.P.* 3-15-58)

1978 Issue Price $108.00

Current Value $112.00

FIGURINES

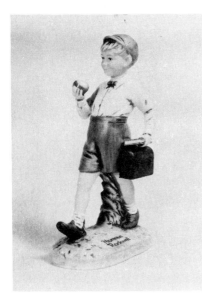

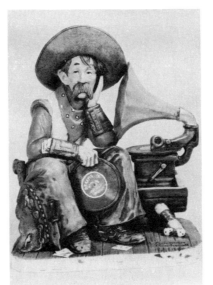

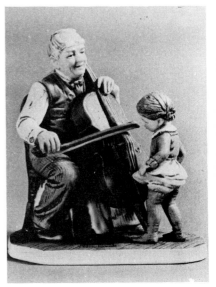

Teacher's Pet NRA-30

Dave Grossman Designs, Inc.

5 inches high

1979 Issue Price $35.00

Back From Camp NR-33

David Grossman Designs, Inc.

6½ inches high (*S.E.P.* 8-24-40)

1979 Issue Price $96.00

Dreams of Long Ago NR-31

Dave Grossman Designs, Inc.

5½ inches high (*S.E.P.* 8-13-27)

1979 Issue Price $100.00

Grandpa's Ballerina NR-32

Dave Grossman Designs, Inc.

6½ inches high (*S.E.P.* 2-3-23)

1979 Issue Price $100.00

Tom Sawyer Series No. 1

Whitewashing Fence TS1

Dave Grossman Designs, Inc.

5¾ inches high, Ltd. Ed. 3,000

1976 Issue Price $60.00

1978 Value $70.00, Edition Closed

Current Value $150.00

FIGURINES

Joys of Childhood Series of Ten

Franklin Porcelain

Franklin Mint

Permanently limited edition

Hopscotch

Coasting Along

Dressing Up

The Nurse

Ride 'Em Cowboy

The Stilt-Walker

The Fishing Hole

Trick or Treat

Time Out

The Marble Champ

3,700 Limited Edition

1976 Issue Price $120.00 each

Current Value $150.00

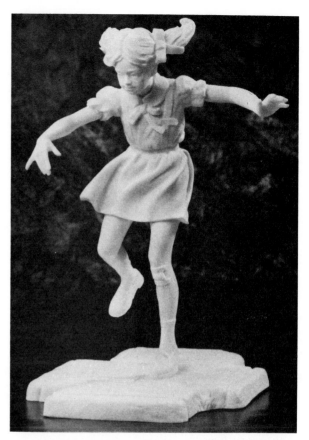

© 1976 Franklin Mint

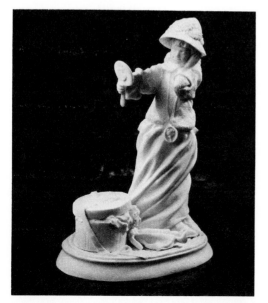

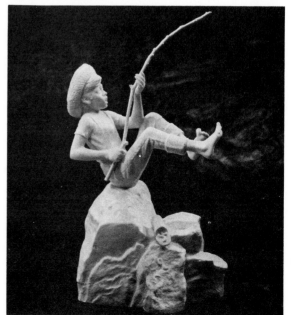

FIGURINES

Tom Sawyer Series No. 2

First Smoke TS2

Dave Grossman Designs, Inc.

3½ inches high, Ltd. Ed.

1977 Issue Price $60.00

1978 Value $70.00 , Edition Closed

Current Value $100.00

Tom Sawyer Series No. 3

Take Your Medicine TS3

Dave Grossman Designs, Inc.

1977 Issue Price $63.00 Limited Edition

1978 Value $70.00

Current Value $100.00

Tom Sawyer Series No. 4

Lost In Cave TS4

Dave Grossman Designs, Inc.

1978 Issue Price $70.00 Limited Edition

Current Value $100.00

MINIATURE FIGURINES

Redhead NR-201

Dave Grossman Designs, Inc.

Height 3½" (*S.E.P.* 9-16-16)

1979 Issue Price $18.00

Back to School NR-202

Dave Grossman Designs, Inc.

Height 3½"(*S.E.P.* 1-8-27)

1979 Issue Price $18.00

Carroler NR-203

Dave Grossman Designs, Inc.

Height 3¾" (*S.E.P.* 12-8-23)

1979 Issue Price $20.00

MINIATURE FIGURINES

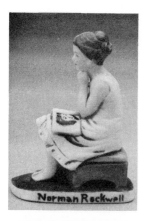

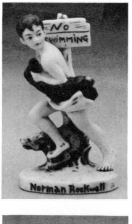

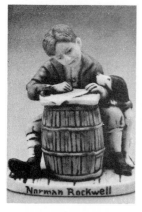

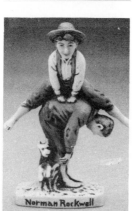

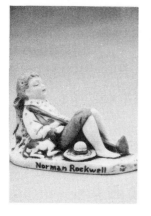

The Daydreamer NR-204

Dave Grossman Designs, Inc.

Height 2½"(*S.E.P.* 3-6-54)

1979 Issue Price $20.00

No Swimming NR-205

Dave Grossman Designs, Inc.

Height 3½" (*S.E.P.* 6-4-21)

1979 Issue Price $22.00

Love Letter NR-206

Dave Grossman Designs, Inc.

Height 3" (*S.E.P.* 1-17-20)

1979 Issue Price $26.00

Lovers NR-207

Dave Grossman Designs, Inc.

Height 3" (*S.E.P.* 8-30-24)

1979 Issue Price $28.00

Lazybones NR-208

Dave Grossman Designs, Inc.

Height 1¾" (*S.E.P.* 9-6-19)

1979 Issue Price $22.00

Leapfrog NR-209

Dave Grossman Designs, Inc.

Height 4" (*S.E.P.* 6-28-19)

1979 Issue Price $32.00

MINIATURE FIGURINES

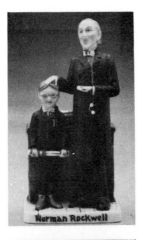

Schoolmaster NR-210

Dave Grossman Designs, Inc.

Height 4" (*S.E.P.* 6-26-26)

1979 Issue Price $34.00

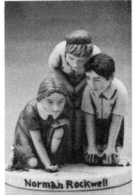

Marble Players NR-211

Dave Grossman Designs, Inc.

Height 3" (*S.E.P.* 9-2-39)

1979 Issue Price $36.00

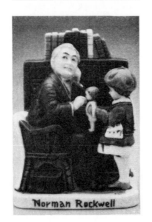

Doctor and Doll NR-212

Dave Grossman Designs, Inc.

Height 3½" (*S.E.P.* 3-9-29)

1979 Issue Price $40.00

LIMITED EDITION PRINTS

Limited edition prints afford the collector a close association with original Rockwell work. Canvas and paper were the artist's media. With the printing technology available today, prints also afford the unscrupulous a medium for fraud and deception. For example, "The Watchmaker," originally published in 1952 by the Swiss Watch Industry, is currently offered for $1,850 as a signed limited edition graphic. It is indeed signed, but what the unsuspecting may not realize is that only the original print was specially signed by Mr. Rockwell; and that copies are reproductions of the one original. 1975 Issue Price $95.00, Current Value $95.00.

A word of caution for investing in limited edition graphics! Buy from an established, reputable gallery or 'caveat emptor . . .' "let the buyer beware." A selection should be based soley upon its aesthetic value to you. Only then will you actually prosper . . . if not in wealth, then, at least in joy.

The Watchmaker

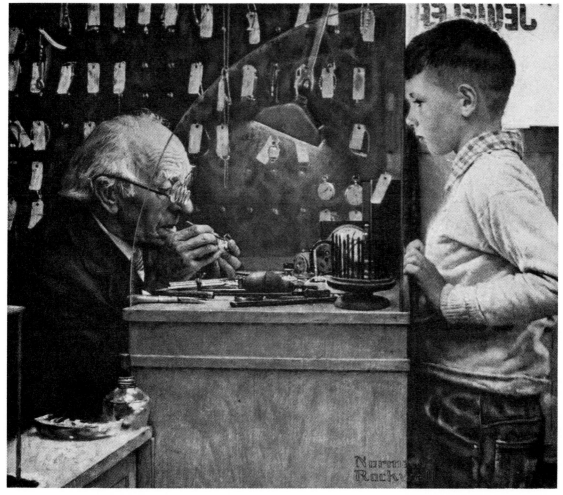

LIMITED EDITION PRINTS

HARRY N. ABRAMS, INC.

Title	Size	Medium (J-Japon)	Size of Edition	Reference Value	Current Value
Breaking Home Ties	25x30	Collo	100	$ 2,500 - '76	$ 8,000
Christmas Trio	25x30	Collo	100	$ 1,000 - '76	$ 5,000
Courting Couple At Midnight	25x30	Collo	100	$ 1,000 - '76	$ 5,000
Four Seasons - Set of 4	25x30	Collo	100	$ 2,500 - '76	$ 3,500
A Time For Greatness	25x30	Collo	100	$ 2,500 - '76	$ 650
Triple Self-Portrait	25x30	Collo	100	$ 3,000 - '76	$13,500
Weighing In	25x30	Collo	100	$ 800 - '76	$ 4,500

10 additional copies of each print were published as artist proofs and numbered AP-A through AP-J.

AMERICAN ARTIST MAGAZINE

Celebration	22x28	Collo	950	$ 125 - '76	$5,000

AMERICAN HERITAGE GRAPHICS

John F. Kennedy	16x21	Litho	228	$ 125 - '76	$2,000

BISSELL INC.

Pals	20x27	Litho	750	Gift - '76	$4,000

THE FRANKLIN MINT

The Collector	20x14	Canvas	136,056	Gift - '73	$1,800 signed

WESTPORT COLLECTORS GUILD

Bridge Over The Seine		Litho	285	$1,070 - '78	$1,400
A Family Tree		Litho	285	$2,075 - '78	$4,500
Homecoming		Litho	285	$ 900 - '76	$4,000
On Top Of The World		Litho	285	$ 980 - '78	$3,000
Raleigh Rockwell Travels		Litho	285	$1,280 - '78	$3,000

CIRCLE GALLERY, LTD.

Title	Size	Medium (J-Japon)	Size of Edition	Reference Value	Current Value
At the Barber	22x30	Litho	200	$2,150 - '76	$ 2,800
Aviary	20x26	Litho	200	$1,000 - '76	$ 4,500
Barbershop Quartet	24x30	Litho	200	$ 800 - '76	$ 2,500

LIMITED EDITION PRINTS

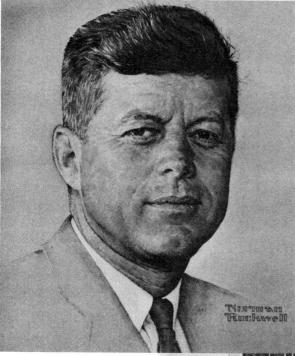

John F. Kennedy

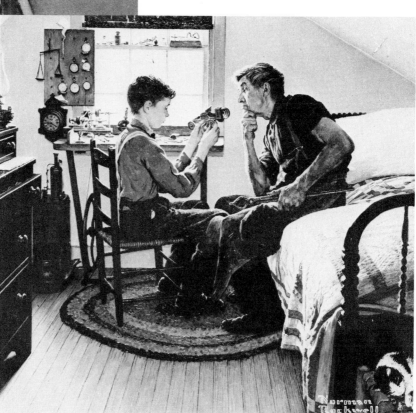

The Inventor

LIMITED EDITION PRINTS

CIRCLE GALLERY, LTD.

Title	Size	Medium (J-Japon)	Size of Edition	Reference Value	Current Value
Blacksmith Shop	14x30	Litho	200	$2,500 - '76	$ 3,500
Bookseller	17x23	Litho	200	$ 600 - '76	$ 3,000
Bookseller	17x23	Litho (J)	25	$ 650 - '76	$ 1,800
The Bridge	20x26	Litho	200	$ 750 - '76	$ 1,800
Children At Window	20x26	Litho	200	$ 600 - '76	$ 1,500
Circus	20x26	Litho	200	$ 700 - '76	$ 2,200
County Agricultural Agent	24x35	Collo	200	$ 850 - '76	$ 3,000
The Critic	28x32	Collo	200	$ 900 - '76	$ 4,500
Day In The Life Of A Boy	19x20	Litho	200	$1,000 - '76	$ 5,000
Day In The Life Of A Boy	19x20	Litho (J)	25	$1,025 - '76	$ 5,050
Discovery	28x32	Collo	200	$ 900 - '76	$ 5,000
Doctor and Boy	20x26	Litho	200	$ 700 - '76	$ 2,200
Doctor and Doll	29x35	Collo	200	$2,000 - '76	$14,000
Dressing Up (Ink)	20x26	Litho	60	$1,000 - '76	$ 3,000
Dressing Up (Pencil)	20x26	Litho	200	$1,400 - '76	$ 3,400
The Expected and Unexpected	17x20	Litho	200	$ 800 - '76	$ 2,100
Family Tree	20x35	Litho	200	$1,200 - '76	$ 4,500
Football Mascot	20x26	Litho	200	$ 600 - '76	$ 2,400
Freedom From Fear	29x35	Collo	200	$ 900 - '76	$ 5,500
Freedom From Want	29x35	Collo	200	$ 900 - '76	$ 5,500
Freedom of Religion	29x35	Collo	200	$ 900 - '76	$ 5,500
Freedom of Speech	29x35	Collo	200	$ 900 - '76	$ 5,500
Gaiety Dance Team	24x30	Collo	200	$1,000 - '76	$ 3,200
Girl At The Mirror	29x35	Collo	200	$1,500 - '76	$ 5,000
Golden Rule	29x35	Collo	200	$1,000 - '76	$ 4,000
Gossips	22x25	Litho	200	$ 750 - '76	$ 3,800
Gossips	22x25	Litho (J)	25	$ 800 - '76	$ 3,850
High Dive	24x30	Collo	200	$ 500 - '76	$ 2,100
The Homecoming	25x30	Litho	200	$ 900 - '76	$ 4,000
The House	20x26	Litho	200	$ 700 - '76	$ 3,200
Ichabod Crane	20x26	Litho	200	$1,600 - '76	$ 5,000
The Inventor	19x19	Litho	200	$ 850 - '76	$ 4,000
Jerry	20x26	Litho	200	$ 700 - '76	$ 4,000
Lincoln	20x26	Litho	200	$2,100 - '76	$ 6,000
Marriage License	28x32	Collo	200	$1,100 - '76	$ 6,000
Moving Day	24x30	Collo	200	$ 700 - '76	$ 3,500
Music Hath Charm	24x30	Collo	200	$ 600 - '76	$ 3,200
Outward Bound	29x35	Collo	200	$1,700 - '76	$11,000
Prescription	24x30	Litho	200	$ 800 - '76	$ 3,800
Prescription	24x30	Litho (J)	25	$ 850 - '76	$ 3,850

LIMITED EDITION PRINTS

The Four Freedoms

LIMITED EDITION PRINTS

CIRCLE GALLERY, LTD.

Title	Size	Medium (J-Japon)	Size of Edition	Reference Value	Current Value
The Problem We All Live With	31x44	Collo	200	$ 550 - '76	$ 3,500
Puppies	20x26	Litho	200	$ 600 - '76	$ 2,200
Raleigh The Dog	29x35	Collo	200	$ 750 - '76	$ 2,800
Rocket Ship	20x26	Litho	200	$ 700 - '76	$ 1,900
Runaway	28x32	Collo	200	$ 900 - '76	$ 3,200
Safe And Sound	17x20	Litho	200	$ 600 - '76	$ 1,800
Saturday People	24x30	Collo	200	$ 700 - '76	$ 3,000
Saying Grace	29x35	Collo	200	$1,200 - '76	$12,000
Schoolhouse	15x18	Litho	200	$ 475 - '76	$ 1,400
Schoolhouse	15x18	Litho(J)	25	$ 525 - '76	$ 1,450
See America First	21x27	Litho	200	$1,600 - '76	$ 4,500
Settling In	20x26	Litho	200	$1,300 - '76	$ 1,800
Shuffleton's Barbershop	28x35	Collo	200	$1,500 - '76	$ 8,000
Spelling Bee	14x30	Litho	200	$2,500 - '76	$ 3,200
Spring Flowers	27x33	Collo	200	$ 900 - '76	$ 6,500
A Study For The Doctor's Office	22x25	Litho	200	$1,100 - '76	$ 5,500
Summer Stock	21x27	Litho	200	$ 900 - '76	$ 3,800
Summer Stock	21x27	Litho(J)	25	$ 950 - '76	$ 3,850
The Teacher	17x23	Litho	200	$ 600 - '76	$ 1,800
The Teacher	17x23	Litho	25	$ 650 - '76	$ 1,850
The Texan	24x30	Collo	200	$ 650 - '76	$ 4,000
Three Farmers	20x16	Litho	200	$ 375 - '77	$ 1,500
Ticket Seller	21x27	Litho	200	$ 750 - '77	$ 3,500
Ticker Seller	21x27	Litho(J)	25	$ 800 - '77	$ 3,550
Top Of The World	29x35	Collo	200	$ 500 - '77	$ 3,000
Trumpeter	21x26	Litho	200	$ 415 - '76	$ 3,200
Trumpeter	21x26	Litho(J)	25	4 465 - '76	$ 3,250
Welcome	20x26	Litho	200	$ 700 - '76	$ 1,400
Wet Paint	24x30	Collo	200	$ 650 - '76	$ 1,200
Window Washer	20x26	Litho	200	$ 600 - '76	$ 1,200

LIMITED EDITION PRINTS

FOLIOS

Title	Size	Medium (J-Japon)	Size of Edition	Reference Value	Current Value
AMERICAN FAMILY				$ 3,500 - '76	$ 4,000
Debut	20x26	Litho	200	$ 700 - '76	$ 800
Fido's House	20x26	Litho	200	$ 700 - '76	$ 800
Save Me	20x26	Litho	200	$ 700 - '76	$ 800
Teacher's Pet	20x26	Litho	200	$ 700 - '76	$ 800
Two O'Clock Feeding	20x26	Litho	200	$ 700 - '76	$ 800
FOUR SEASONS				$ 2,400 - '76	$ 4,000
Spring	20x21	Litho	200	$ 650 - '76	$ 1,000
Summer	20x21	Litho	200	$ 650 - '76	$ 1,000
Autumn	20x21	Litho	200	$ 650 - '76	$ 1,000
Winter	20x21	Litho	200	$ 650 - '76	$ 1,000
FOUR SEASONS				$ 2,560 - '76	$ 3,500
Spring	20x21	Litho (J)	25	$ 690 - '76	$ 875
Summer	20x21	Litho (J)	25	$ 690 - '76	$ 875
Autumn	20x21	Litho (J)	25	$ 690 - '76	$ 875
Winter	20x21	Litho (J)	25	$ 690 - '76	$ 875
HUCK FINN				$10,000 - '76	$12,500
Jim Got Down On His Knees	20x26	Litho	200	$ 1,500 - '76	$ 1,560
Miss Mary Jane	20x26	Litho	200	$ 1,500 - '76	$ 1,560
My Hand Shook	20x26	Litho	200	$ 1,500 - '76	$ 1,560
Then For Three Minutes	20x26	Litho	200	$ 1,500 - '76	$ 1,560
Then Miss Watson	20x26	Litho	200	$ 1,500 - '76	$ 1,560
There Warn't No Harm	20x26	Litho	200	$ 1,500 - '76	$ 1,560
When I Lit My Candle	20x26	Litho	200	$ 1,500 - '76	$ 1,560
Your Eyes Is Look'in	20x26	Litho	200	$ 1,500 - '76	$ 1,560
POOR RICHARD'S ALMANACK				$ 6,000 - '76	$ 6,500
Ben's Bells	20x26	Litho	200	$ 900 - '76	$ 930
Ben Franklin's Philadelphia	20x26	Litho	200	$ 900 - '76	$ 930
The Drunkard	20x26	Litho	200	$ 900 - '76	$ 930
The Golden Age	20x26	Litho	200	$ 900 - '76	$ 930
The Golden Crown	20x26	Litho	200	$ 900 - '76	$ 930
The Village Smithy	20x26	Litho	200	$ 900 - '76	$ 930
Ye Olde Print Shop	20x26	Litho	200	$ 900 - '76	$ 930

LIMITED EDITION PRINTS

Raleigh Rockwell Travels

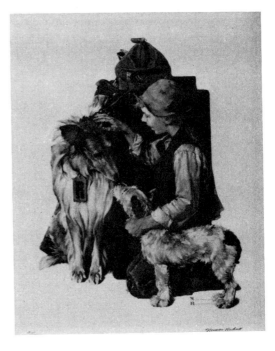

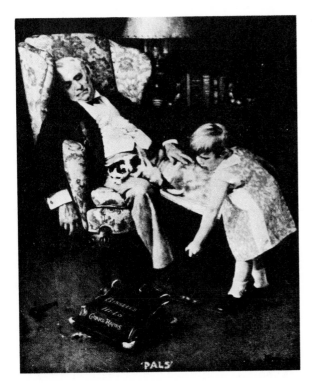

Bissell Girl

LIMITED EDITION PRINTS

FOLIOS

Title	Size	Medium (J-Japon)	Size of Edition	Reference Value	Current Value
SCHOOL DAYS				$ 3,600 - '76	$ 4,200
Baseball	20x26	Litho	200	$ 900 - '76	$ 1,050
Cheering	20x26	Litho	200	$ 900 - '76	$ 1,050
Golf	20x26	Litho	200	$ 900 - '76	$ 1,050
Studying	20x26	Litho	200	$ 400 - '76	$ 1,050
TOM SAWYER				$ 9,000 - '76	$10,000
Cat	20x26	Litho	200	$ 1,150 - '76	$ 1,250
Church	20x26	Litho	200	$ 1,150 - '76	$ 1,250
Grotto	20x26	Litho	200	$ 1,150 - '76	$ 1,250
Medicene	20x26	Litho	200	$ 1,150 - '76	$ 1,250
Out The Window	20x26	Litho	200	$ 1,150 - '76	$ 1,250
Smoking	20x26	Litho	200	$ 1,150 - '76	$ 1,250
Spanking	20x26	Litho	200	$ 1,150 - '76	$ 1,250
Whitewashing	20x26	Litho	200	$ 1,750 - '76	$ 1,250
TOM SAWYER COLOR SUITE	20x26	Collo	200	$ 8,500 - '78	$ 9,000

ELEANOR ETTINGER, INC.

Title	Size	Medium (J-Japon)	Size of Edition	Reference Value	Current Value
After Christmas		Litho	260	$1,000 - '78	$2,000
After Christmas		Litho (J)	25	$1,100 - '78	$2,700
After The Prom	24x26¾	Litho	260	$1,500 - '78	$4,500
After The Prom	24x26¾	Litho (J)	25	$1,500 - '78	$4,550
America Marches Ahead	20x35½	Litho	260	$ 850 -'76	$ 900
April Fool	24x26	Collo	260	$1,000 - '76	$2,500
Back From Camp	21x28	Litho	260	$1,100 - '78	$2,000
Back From Camp	21x28	Litho (J)	25	$1,200 - '78	$2,050
Ben Franklin	21x28	Litho	260	$3,000 - '78	$3,500
Ben Franklin	21x28	Litho (J)	25	$3,100 - '78	$3,550
Boy On Stilts	24x31	Litho	260	$ 900 - '76	$2,100
Boy On Stilts	24x31	Litho (J)	25	$1,000 - '78	$2,150
Buttercup	21x24	Litho	260	$1,000 - '76	$3,000
Buttercup	21x24	Litho (J)	25	$1,200 - '76	$3,050
Can't Wait	24x30	Litho	260	$1,200 - '78	$2,500
Can't Wait	24x30	Litho (J)	25	$1,300 - '78	$2,550
Catching The Big One	26½x34½	Litho	260	$1,000 - '78	$2,200
Catching The Big One	26½x34½	Litho (J)	25	$1,050 - '78	$2,250
Charwomen	25x31½	Collo	260	$ 700 - '76	$2,800
Child's Surprise		Litho	260	$1,100 - '78	$3,000
Child's Surprise		Litho (J)	25	$1,100 - '78	$3,550

LIMITED EDITION PRINTS

ELEANOR ETTINGER, INC.

Title	Size	Medium (J-Japon)	Size of Edition	Reference Value	Current Value
Colonial Sign Painter		Litho	260	$1,000 - '76	$2,500
Convention		Collo	260	$1,000 - '78	$1,400
Dreams Of Long Ago		Litho	260	$2,800 - '78	$3,500
Dreams Of Long Ago		Litho (J)	25	$3,000 - '78	$3,550
Extra Good Boys & Girls		Litho	260	$2,000 - '78	$2,500
Extra Good Boys & Girls		Litho	25	$2,100 - '78	$2,550
Football Hero		Litho	260	$ 900 - '78	$1,500
Football Hero		Litho (J)	25	$ 950 - '78	$1,550
Gilding The Eagle	21x25½	Litho	260	$1,400 - '78	$2,400
Gilding The Eagle	21x25½	Litho (J)	25	$1,500 - '78	$2,450
Hayseed Critic	21¼x27	Litho	260	$1,000 - '78	$2,000
Hayseed Critic	21¼x27	Litho (J)	25	$1,100 - '78	$2,050
Horseshoe Forging Contest	30x18	Collo	Rives	$3,000 - '78	$4,800
Jester	20½x25	Litho	260	$ 900 - '78	$1,000
Jester	20½x25	Litho (J)	25	$1,000 - '78	$1,050
Muggleton Stagecoach	20x25½		260	$2,200 - '78	$3,000
Racer		Litho	260	$ 900 - '78	$1,400
Racer		Litho (J)	25	$ 950 - '78	$1,450
Rejected Suitor	21x26	Litho	260	$1,000 - '78	$1,800
Rejected Suitor	21x26	Litho (J)	25	$1,100 - '76	$1,800
The Rivals	21¼x22¼	Litho	260	$1,000 - '76	$3,200
She's My Baby		Litho	260	$1,100 - '78	$2,100
She's My Baby		Litho (J)	25	$1,200 - '78	$2,150
The Swing	20x21	Litho	260	$1,500 - '78	$2,200
The Swing	20x21	Litho (J)	25	$1,600 - '78	$2,250
Three Boys Fishing		Collo	260	$1,000 - '78	$1,800
Top Hat And Tails		Litho	260	$3,500 - '78	$4,800
Voyager	25½x32½	Collo	260	$3,000 - '78	$3,800
The Wind Up	26x29½	Litho	260	$2,000 - '78	$3,000
The Wind Up	26x29½	Litho (J)	25	$2,200 - '78	$3,050
Young Lincoln	19x34	Litho	260	$5,000 - '78	$6,000
Young Lincoln	19x35	Litho (J)	14	$5,300 - '78	$6,050
Young Spooners	21x28	Litho	260	$1,600 - '78	$4,500
Young Spooners	21x28	Litho (J)	25	$1,700 - '78	4,550

FOLIO

Title	Size	Medium (J-Japon)	Size of Edition	Reference Value	Current Value
Puppy Love	20x21½	Litho	260	$6,000 - '78	-
Puppy Love	20x21½	Litho (J)	25	$6,200 - '78	-
Sports Portfolio	20¼x24½	Litho	260	$4,500 - '78	-
Sports Portfolio	20¼x24½	Litho (J)	25	$4,700 - '78	-

MEDALS, COINS, INGOTS

In 1953 Norman Rockwell was commissioned by the Ford Motor Company to paint a series of eight paintings to commemorate the Company's 50th anniversary. Those paintings were used on prints, calendars, ads, portraits, medals and plastic coins, etc.

One of the illustrations, a triple-portrait of Henry Ford, Edsel and Henry II was the inspiration for a one-half inch square 10K gold thirty year company pin.

In 1963 the Ford Motor Company struck a one-half pound bronze medal or paper-weight, inspired by the 1953 Rockwell illustration "Henry Ford in His First Workshop." The medal is stamped, "Henry Ford Centennial 1863-1963."

Since that time The Franklin and Hamilton Mints have issued several successful series in both medals and ingots. The value of gold and silver has soared in recent years, and Norman Rockwell inspired collectibles have kept pace, particularily since Mr. Rockwell's death in 1978.

Henry Ford's First Car Medal

Ford Motor Company 1863-1963 Centennial

Bronze Design Commemorating Henry Ford's

Birth on July 30, 1863.

1963 Issue Price (A Gift)

1978 Value $150.00

Current Value $160.00

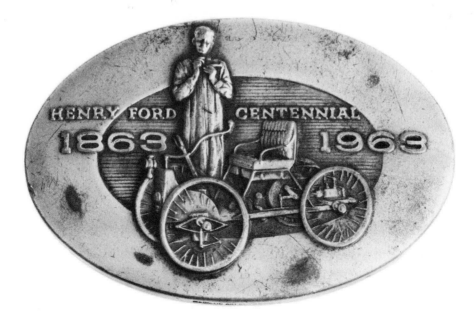

MEDALS

Henry Ford Family Triple Portrait Medal

Ford Motor Company

Designed by DeFrancisi

Fifty Years Forward on the American Road

This symbol became the Ford logo throughout

the 50th Anniversary (1953) year.

1953 Issue Price (A Gift)

1978 Value $110.00

Current Value $125.00

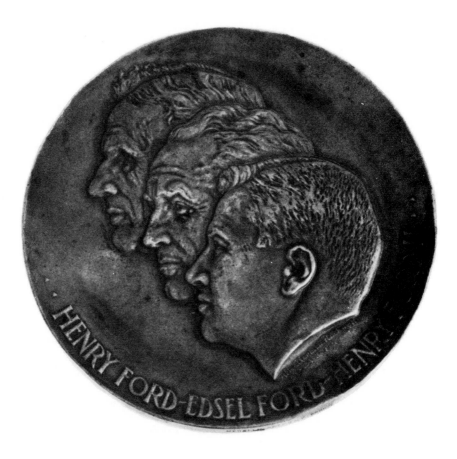

The Official Girl Scout Medals

Franklin Mint

1½ inch diameter, set of twelve

"On My Honor" — Promise(GSC-1)

Law 1 *Honest* (GSC-2)

Law 2 *Fair* (GSC-3)

Law 3 *Helpful* (GSC-4)

Law 4 *Cheerful* (GSC-5)

Law 5 *Kind* (GSC-6)

Law 6 *Sisters* (GSC-7)

Law 7 *Respectful* (GSC-8)

Law 8 *Resourceful* (GSC-9)

Law 9 *Concerned* (GSC-10)

Law 10 *Considerate* (GSC-11)***
"Be Prepared" — Motto (GSC-12)

Limited Edition Sterling Silver-2,182 produced

1977 Issue Price $234.00 Current Value $400.00

Limited Edition Franklin bronze — 1,996 produced

1977 Issue Price $114.00 set Current Value $200.00

Limited Edition Solid 24 Karat Gold 20 produced

1977 Issue Price $3,000.00 set of 12 Current Value $3,500.00

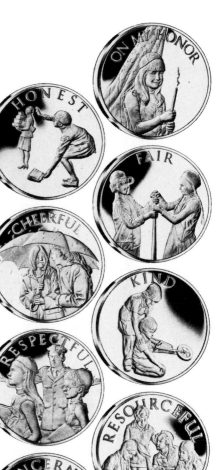

© The Franklin Mint

*** GSC-11 (CONSIDERATE) was minted by error with #10 on the reverse. This is in Bronze *only* and was discovered before the silver medals were minted. The Franklin Mint permitted subscribers to exchange the medal for the correct variety; retain the error and purchase the correct variety additionally — whichever they preferred. As a result, there is a net mintage of 560 of the error variety outstanding.

MEDALS

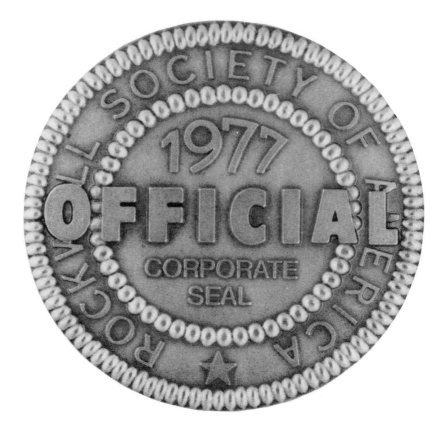

Rockwell Society of America Medal

Bronze Corporate Seal No. 1

Four ounce, 2½ inch diameter

1977 Issue Price (a gift to membership)

Rockwell Society of America Medal

Bronze Corporate Seal No. 3

Four ounces, 2½" diameter

1979 Issue Price (a gift to membership)

Rockwell Society of America Medal

Bronze Corporate Seal No. 2

Four ounce, 2½ inch diameter

1978 Issue Price (a gift to membership)

MEDALS

The Saturday Evening Post

250th Anniversary Medal

The Hamilton Mint

.999 Fine Silver, 2 inch diameter

1977 Issue Price $30.00

Current Value $40.00

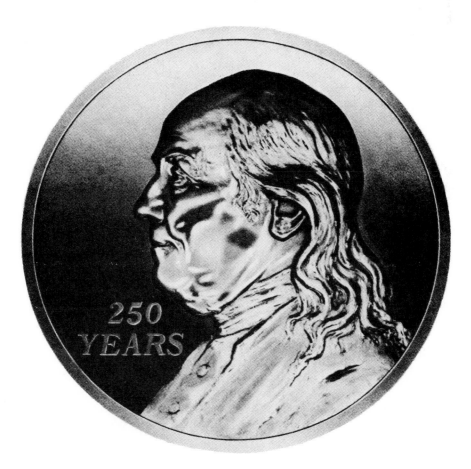

MEDALS

Spirit of Scouting Medals

Boy Scouts of America for

Franklin Mint-proof edition 26,971

Sculpted by Richard Baldwin

Sterling silver, art medals

Series of twelve.

A Boy Scout Is:

Trustworthy (SSS-1)

Loyal (SSS-2)

Helpful (SSS-3)

Friendly (SSS-4)

Courteous (SSS-5)

Kind (SSS-6)

Obedient (SSS-7)

Cheerful (SSS-8)

Thrifty (SSS-9)

Brave (SSS-10)

Clean (SSS-11)

Reverent (SSS-12)

1972 Issue Price $9.75 per medal

1978 Value $145.00

Current Value $250.00

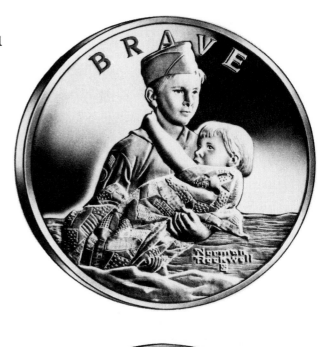

© 1972 Franklin Mint

MEDALS

Tribute To Robert Frost

Franklin Mint-12,544 minted

Sterling silver proof sets

of twelve original works

by Norman Rockwell:

After Apple Picking (RTF-1)

The Road Not Taken (RTF-2)

Dust of Snow (RTF-3)

Stopping by Woods on a Snowy Evening (RTF-4)

Going For Water (RTF-5)

Mending Wall (RTF-6)

The Gift Outright (RTF-7)

Birches (RTF-8)

A Mood Apart (RTF-9)

The Pasture (RTF-10)

A Time to Talk (RTF-11)

The Grindstone (RTF-12)

1974 Issue Price $25.00 each medal

1978 Value $345.00 set of 12

Current Value $375.00 set of 12

© 1974 Franklin Mint

COINS

Fifty Years Forward With Ford 1903-1953

Ford Motor Company 50th Anniversary Coin

Triple Family Portrait of Henry, Edsel and Henry Ford II

In-relief copper; and, red, gold, and blue plastic containing

opening for key chain.

1953 Issue Price (A Gift)

1978 Value $10.00

Current Value $15.00

The Four Seasons

The Hamilton Mint

1½ inch diameter, 480 gr. S.S.

Limited Edition Subscription

Spring, Summer, Autumn, Winter

1976 Issue Price $14.00 each medal

Current Value $60.00 set of 4

Four Freedoms Coins

Kennedy Mint, set of four Not Pictured

In walnut frame

1976 Issue Price $25.00 each coin

Current Value $120.00 set of 4

INGOTS

Favorite Moments From Mark Twain

Franklin Mint Ingots

4,544 Sterling Silver

1,220 Franklin Bronze

2 inch x 1⅝ inch, 700 grains

The Adventures of Tom Sawyer (RMT-1)

The Adventures of Huckleberry Finn (RMT-2)

Life on the Mississippi (RMT-3)

Roughing It (RMT-4)

A Connecticut Yankee In King Arthur's Court (RMT-5)

The Prince and the Pauper (RMT-6)

The Celebrated Jumping Frog of Calaveras County (RMT-7)

Innocents Aboard (RMT-8)

Pudd'n Head Wilson (RMT-9)

Tom Sawyer, Detective (RMT-10)

1975 Issue Price solid bronze $120.00 set of ten

1975 Issue Price sterling silver $290.00 set of ten

1978 Value solid bronze $100.00/$140.00
Current Value $150.00

1978 sterling silver $190.00/$290.00
Current Value $350.00

© 1975 Franklin Mint

INGOTS

Four Freedoms

The Hamilton Mint Silver Ingots

.999 Fine Silver, 1¾ x 2½

1974 Issue Price $22.95 each, $91.80 set in silver

1974 Issue Price $27.95 24Kt. gold on silver

1978 Value $175.00 per set in silver

1978 Value $150.00

Current Value $180.00

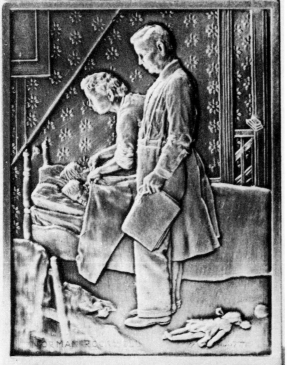

INGOTS

Norman Rockwell's Fondest Memories

Franklin Mint Sterling Silver Ingots

2 inches x 2½ inches, set of ten

Serially numbered proofs. 23,532 produced

Proof-like (1976) 1,282 produced

At The Barber (RMI-1)

Holiday Dinner (RMI-2)

The Checker Game (RMI-3)

Fun On The Hill (RMI-4)

The First Date (RMI-5)

The Knitting Lesson (RMI-6)

The Patient (RMI-7)

Playing Hookey (RMI-8)

Day Off (RMI-9)

The Big Parade (RMI-10)

1973 Issue Price $25.00 Per Ingot Current Value $300.

1976 Issue Price (Proof-Like) $370.00 set

1978 Value $250.00 Per Set (1973 Issue)

Current Value $420.00

© 1973 Franklin Mint

INGOTS

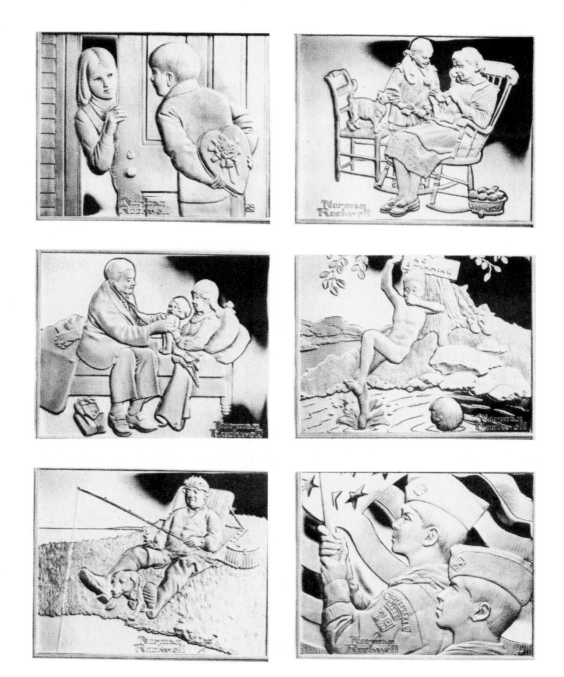

Norman Rockwell's Fondest Memories

INGOTS

Portraits of America

Hamilton Mint

1¼ x 1¾, Series of twenty-four ingots

10,000 Sets in fine silver

5,000 Sets in gold on silver

1977 Issue Price fine silver each ingot $22.00
Current Value $25.00

1977 Issue Price gold on silver $30.00 each ingot
Current Value $35.00

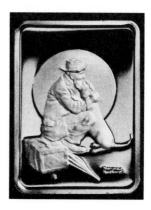

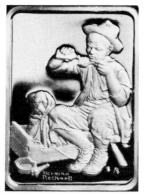

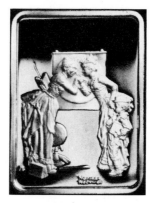

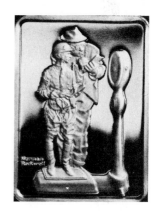

INGOTS

Santa Planning Visit

The Hamilton Mint

Christmas Art Ingot No. 3

24KT gold/.999FS

1978 Issue Price $25.00/.999FS

1978 Issue Price $32.50/24KT gold/FS

Current Value $37.50

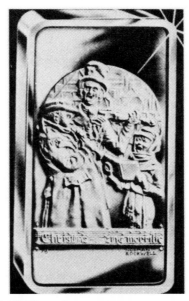

Christmas Trio

The Hamilton Mint Ingot

1¼ x 1¾ inch

1974 Issue Price .999 fine silver $12.50 each

1974 Issue Price 24 Kt. gold on pure silver $12.50 each

1978 Value $15.00 Current Value $25.00

INGOTS

Slumbering Santa Ingot

Hamilton Mint Christmas

1¼ x 1¾ inch sterling silver

1¼ x 1¾ inch — gold on .999 F.S.

1975 Issue Price $15.00 — S.S.

1978 Value $25.00

1975 Issue Price $20.00 24Kt. gold on F.S.

1978 Value $35.00

Value Unchanged

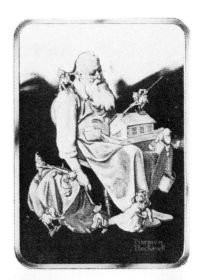

Tiny Tim Ingot

The Hamilton Mint

1¼ x 1¾ inch

1976 Issue Price, .999 fine silver $15.00

1976 Issue Price, 24Kt. gold on silver $20.00
Current Value $25.00

Charles Dickens Ingot

Hamilton Mint

.999 Fine Silver

24 Kt. gold/.999 F.S.

1977 Issue Price $22.50/.999 F.S.

Current Value $25.00

1977 Issue Price 24Kt. Gold/F.S. $35.00

Current Value $45.00

INGOTS

Twelve Best Loved 'Post' Covers

Hamilton Mint Ingots

The First 'Post' Cover (May 20, 1916)

Doctor and Doll (March 9, 1929)

Tattooist (March 4, 1944)

Man Threading A Needle (April 8, 1922)

Dreams of Long Ago (August 13, 1927)

Springtime (April 16, 1927)

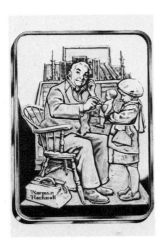

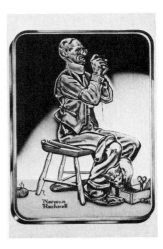

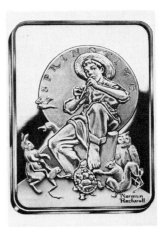

INGOTS

Shuffleton's Barbershop (April 29, 1950)

Saying Grace (November 24, 1951)

Breaking Home Ties (September 25, 1954)

Triple Self-Portrait (February 13, 1960)

All American (May 18, 1918)

First Radio (May 20, 1922)

1975 Issue Price 10,000 silver editions $13.75 each

1975 Issue Price 5,000 gold editions $18.75 each

1978 Value silver $117.00 per set of twelve
Current Value $120.00 per set of twelve

1978 Value gold $195.00
 per set of twelve

Current Value $200.00
 per set of twelve

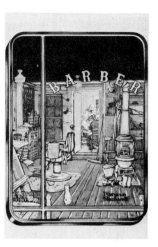

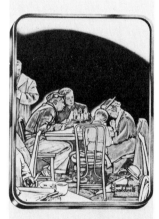

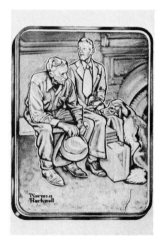

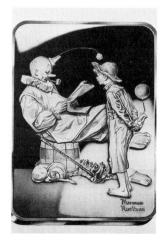

MISCELLANEOUS

This chapter serves to identify new areas of potential collectibles while listing established items that may be unique or relatively inactive as a collectible, such as bowls.

Most new items will be listed under miscellaneous unless the category has already been established. Rumbleseat Press' first Norman Rockwell Character Doll, "Mimi" and Gorham's **cache'pots** represent two new exciting collectibles. And, what could be more unique than the previously unrecorded coin-bank of the 40's?

New trends can be identified very early by noting new listings in this chapter.

The astute collector will not hesitate to purchase a first edition, or an unusual offering, provided the "First Commandment" of collecting is considered, "Buy what you like." If you like something, others will feel the same way about it. That's what collecting is all about.

1918 Sheet Music

Over There

Words and music by George M. Cohan

1978 Value $25.00

Value Unchanged

1918 Sheet Music

Over Yonder Where the Lilies Grow

By Geoffrey O'Hara

1978 Value $35.00

Value Unchanged

1918 Sheet Music

Good-bye, Little French Mother

1978 Value $35.00

Value Unchanged

Family Sing Along With Mitch

Published by Robbins Music Corporation

Recorded by Mitch Miller and the Gang

1962 Issue Price $2.00

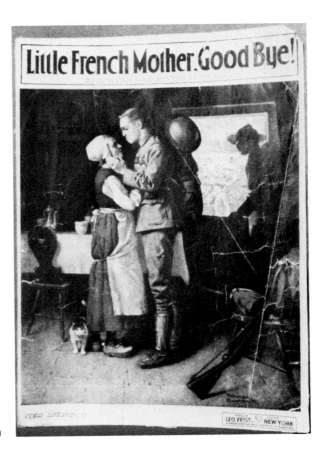

MISCELLANEOUS

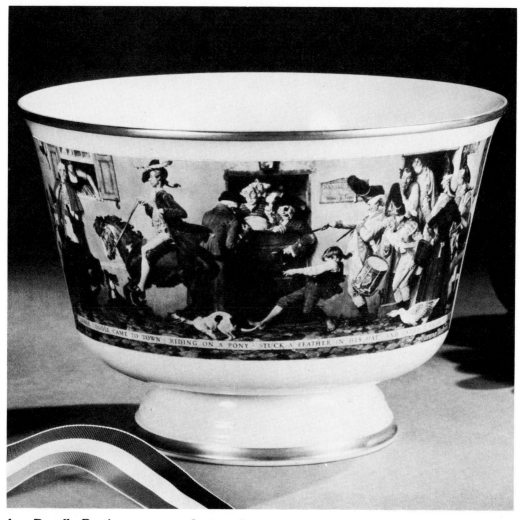

Yankee Doodle Bowl Gorham Fine China 9,800 signed and numbered

Bicentennial Centerpiece 8½ inches diameter 1975 Issue Price $50.00

 Current Value $95.00

MISCELLANEOUS

Tavern Sign Painter Bowl

Bicentennial Centerpiece,

Offered in 1976, but not

produced.

Ben Franklin Bowl

Danbury Mint

8½ inches diameter, 5½ inches high

1976 Issue Price $65.00

Current Value $115.00

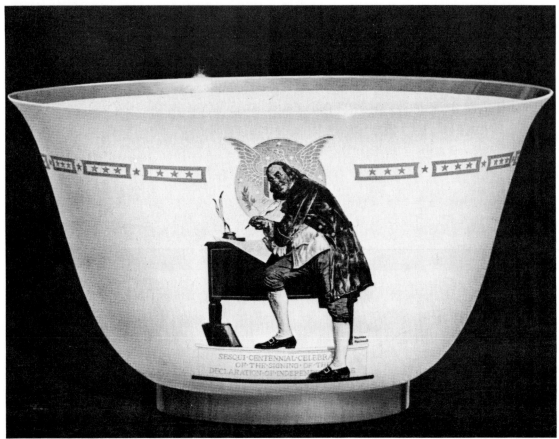

MISCELLANEOUS

Edison Mazda Sales Builder Promotional Magazine

Contains series of illustrations

Rockwell painted for Edison Mazda Lamps

As published in *S.E.P.* Circa 1922

1978 Value $100.00 complete set

Current Value $110.00

Edison Mazda Ink Blotter

Published in 1920

1978 Value $20.00

Current Value $25.00

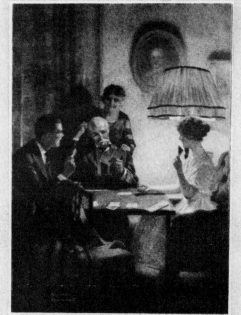

EDISON MAZDA LAMPS

This is the Room That Light-Made

W. L. HOYLE
Dainelson, Connecticut

BLOTTER 272 11-11-20

Tom Sawyer Window Display Card

Coca-Cola 1932

1978 Value $75.00

Current Value $90.00

Boy Fishing Window Display Card

Coca-Cola 1935

1978 Value $70.00

Current Value $90.00

MISCELLANEOUS

Tom Sawyer Ink Blotter

Coca-Cola 1932

1978 Value $35.00

Current Value $40.00

Schmidt's Beer, Ink Blotter

Schmidt's Brewery — 1935

6 x 3¼ inches

1978 Value $14.50

Current Value $20.00

Schmidt's Beer, Window Card

Schmidt's City Beer — 1935

(four men playing cards)

24 inches x 36 inches

1978 Value $50.00

Current Value $90.00

Courtesy Diane Tisch

MISCELLANEOUS

Dear Brighteyes . . .

Doctor & Doll Ink Blotter

Published in 1937

1978 Value $15.00
Current Value $20.00

Tom Sawyer Note Paper

Coca-Cola Circa 1930-1934

5½ inches x 9 inch tablet

1978 Value $25.00

Current Value $30.00

Golden Gate Bridge Fiesta

Program celebrating completion

Golden Gate Bridge — 1937

6 inches x 10 inches and 48 pages

1978 Value $18.00
Current Value $25.00

A Boy Scout is Reverent

Boy Scouts of America fan

Same as 1940 Boy Scout calendar

1978 Value $18.00
Value Unchanged

The Lineman — 1949 Adv.

Used as a 1976 advertising give-away

poster by A T & T — 1976

1978 Value $4.00 Current Value $10.00

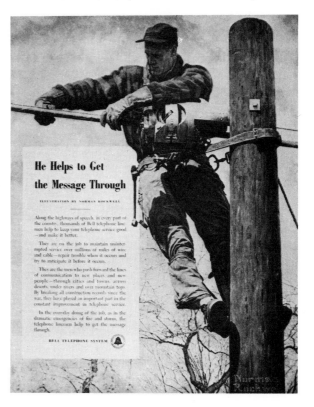

MISCELLANEOUS

Pepsi Cola Santa Claus Poster

Cardboard stand-up type circa 1949

Five feet high 1978 Value $75.00

Twenty inches high 1978 Value $45.00

Value Unchanged

Four Seasons in Sports circa 1951

A Collector's Album of Foilcraft Prints

Four foil prints in portfolio

1978 Value $20.00
Current Value $28.00

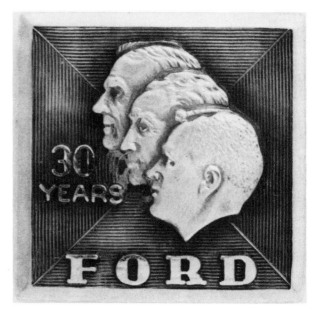

Ford Motor Company — 1953

Press packet outlining the

Company's 50th anniversary celebration

1978 Value $125.00
Current Value $150.00

Triple Portrait

Ford Motor Company lapel pin

1978 Value $30.00

Ford Motor Company Key Chain

Momento of 50th anniversary

Red, blue and opaque plastic coins

with portraits of Henry, Edsel and

Henry II. **Fifty Years Forward on**

the Open Road 1903 — 1953

1978 Value $15.00

Value Unchanged

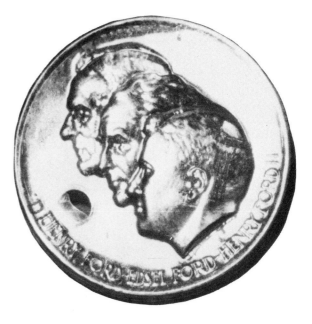

MISCELLANEOUS

Single-Minded Young Man

Kellogg's Cornflakes box — 1954

1978 Value $15.00
Current Value $20.00

Little Rosy Faced Girls

Kellogg's Cornflakes box - 1954

1978 Value $15.00
Current Value $20.00

Freckles

Kellogg's Cornflakes box — 1954

1978 Value $15.00
Current Value $20.00

Two Don't Forgetters

Kellogg's Cornflakes box — 1954

1978 Value $15.00
Current Value $20.00

Pig-Tailed Young Lady

Kellogg's Cornflakes box — 1954

1978 Value $15.00
Current Value $20.00

MISCELLANEOUS

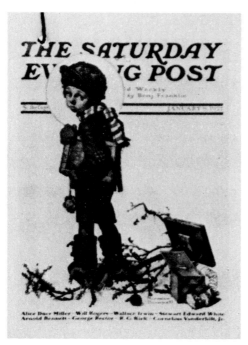

Miniature *Post* Covers

Dave Grossman Designs, Inc.

Figurine promotion — 1974

1978 Value $5.00
 Value Unchanged

Family Portrait Contest Flyer

Sponsored by Yuban Coffee — 1974

1978 Value $5.00

Value Unchanged

The Doctor and the Doll

Woodsmith Gallery — 1974

14" x 11" fitted with brass hanger

1978 Value $20.00

Value Unchanged

Picture Rooms for Your Home

Brochure by Jewel Paint Co. — 1959

1978 Value $10.00
Current Value $12.00

Norman Rockwell Sketches World's

Most Famous Beach Portfolio — circa 1961

Daytona Beach Chamber of Commerce

1978 Value $25.00
Current Value $30.00

Actor Peter Lind Hayes Portrait

on personal stationery — 1964

1978 Value $8.00

Value Unchanged

Norman Rockwell Portfolio

Fidelity Bank, Phila., Pa.

Six pencil portraits

1978 Value $15.00
Current Value $18.00

Barnsdall Park Art Exhibit

Catalog — 1966

1978 Value $12.00
 Value Unchanged

MISCELLANEOUS

Framed portrait of Henry Ford

Edsel and Henry Ford II — 1953

Ford Motor Company's 50th Anniversary

1978 Value $200.00
Current Value $210.00

Watson — Guptill Catalog

Circa 1973

1978 Value $5.75

Value Unchanged

The American Road — 1953

A film made by the Ford Motor Company

in celebration of 50th anniversary.

In this film, Norman Rockwell describes

his Ford anniversary paintings. 16 mm

sound, in color, 28 minutes — 6 pound

shipping weight. Cleared for TV.

No value established.

Tom Sawyer Stamp Key Chain

Comm. collection by Brass Smith House

Authentic mint postage stamp (1972)

Cast in crystal jewelers enamel

1978 Value $8.00

Value Unchanged

Help the Handicapped Window Card

Goodwill Industries, circa 1950

1978 Value $25.00
Current Value $30.00

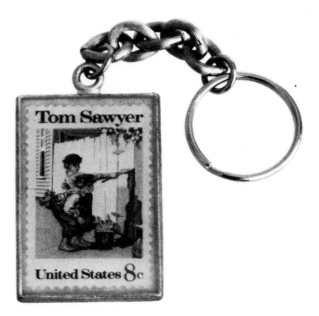

MISCELLANEOUS

Winter in Stockbridge Print

Autographed by N.R.

1978 Value $345.00

Current Value $500.00

Norman Rockwell's World, An American Dream

Produced in 1972

N. R. Narrates the story of his life

in Stockbridge. Nominated and won Academy Award

in short subjects, live action film

No value established

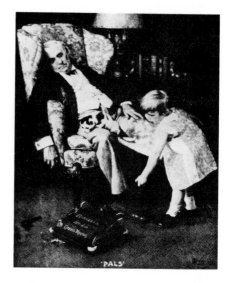

Pals

Bissell Corporation Limited Edition

Advertising promotion of 1929

Reproduced in a very limited number

in 1976. Current Value $30.00

Looking Out To Sea Annual Report

Arts and Leisure Corporation — 1974

1978 Value $8.00

Value Unchanged

Four Seasons Woodprints

Woodsmith Gallery — 1974

8" x 8" Limited to 1950 sets

Issue Price $19.95

1978 Value $25.00

Lady Bird Cha Cha Cha Sheet Music

By Samuel Starr

1978 Value $8.00

Current Value $15.00

MISCELLANEOUS

ADVERTISEMENTS and ILLUSTRATIONS

Individual advertisements date 1916 to 1919 Current Value $15.00

Individual advertisements dated 1920 to 1940 Current Value $10.00

Individual advertisements dated 1940 to 1971 Current Value $5.00

Early color illustrations and ads are scarce. They should be valued higher than black and white illustrations. Of course, condition is the determining factor.

A COMPLETE SET, 323 COPIES, OF THE SATURDAY EVENING POST MAGAZINES WITH NORMAN ROCKWELL COVERS IN EXCELLENT CONDITION, $10,000.00

INDIVIDUAL

THE SATURDAY EVENING POST Covers (good condition)

Curtis Publishing Company

First Norman Rockwell Post cover Current Value $125.00

Complete magazines, dated 1916 to 1919, Current Value $30.00 each

Complete magazines, dated 1920 to 1940, Current Value $15.00 each

Complete magazines, date 1940 to 1971, Current Value $12.00 each

The J.F.K. portrait of April 6, 1963 was the last original Rockwell to appear on the Post. All recent covers have been reproductions of earlier covers, except, Summer - 1971, which was a photograph.

MAGAZINE COVERS

It would be redundant to repeat the values for the 80 other publications Mr. Rockwell worked for. The current values listed for the "Post" covers can apply to all other covers.

MISCELLANEOUS

Famous Artist School Oil Painting Kit

24 piece set including instruction book

1975 Issue Price $17.95

1978 Value $24.00

Value Unchanged

Forty Scouting Prints

Boy Scouts of America — 1975

1" x 12" Full Color

1976 Value $35.00

1978 Value $45.00
Current Value $60.00
Signed $200.00 each

Norman Rockwell Needlecraft Kits

10" x 12" — 1975

The Trading Post

Puppy Love

Football

Baseball

Artist Sweethearts

Little Doctor

Marbles

Issue Price $8.95

1978 Value $12.00

Value Unchanged

Illustrated Paper Dresses

James Sterling Paper Fashions, Ltd.

As advertised in "Look" magazine, 8/20/68

1978 Value $30.00

Current Value $40.00

MISCELLANEOUS

Illustrated Place Mats

12" x 16" — 1973

After the Prom

Homecoming G.I.

Saying Grace

Marriage License

Breaking Home Ties

Shuffleton's Barbershop

Offered by *S.E.P.*

1978 Value $8.00 set
Current Value $10.00

Beam's Bicentennial Limited Editions

Featuring six Norman Rockwell covers

From the distillers of Jim Beam Corp.

Issue Price in 1976 $6.99

1978 Value $10.00

Value Unchanged

MISCELLANEOUS

Autographed material — letters on Rockwell stationery, prints, adv., illustrations, etc.

1976 Value $50.00

1978 Value $75.00
Current Value $200.00

Christmas Card Box (empty)

Hallmark Greeting Cards

Three Color Illustrations

1978 Value $5.75
Current Value $7.00

Norman Rockwell Needlepoint

Playing Marbles

First Dance

Little Doctor

Somersault

From Fairfield House — 1975

Issue Price $14.95

1978 Value $18.00

Current Value $20.00

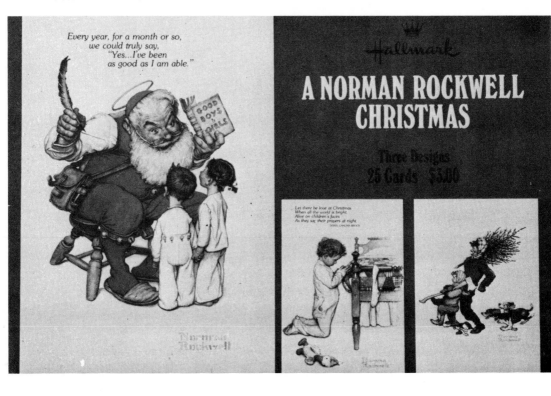

MISCELLANEOUS

America At Work Window Card

Red Wing Shoe Company

Set of four

1978 Value $25.00
Current Value $28.00

Window Cards

Dixon-Ticonderoga Pencil Co.

Set of three

1978 Value (unestablished)
Current Value $25.00

T'was the Night Before Christmas

Record Album by Decca Records

N.R. illustrated slip case

1978 Value $18.00
Current Value $20.00

Pure Prairie League

Record album slip case

1978 Value $8.00
Current Value $12.00

Mike Bloomfield and Al Kooper

Record album slip case — 1968

1978 Value $8.00
Current Value $10.00

A Portrait of Duke — 1974

Film produced for National

Cowboy Hall of Fame, by Ken Meyer.

Made at the time John Wayne posed

for his portrait by Norman Rockwell.

No value established

Waste Baskets

Too Numerous to Compile

No Established Value

MISCELLANEOUS

Stagecoach

A record album incorporating the music from the movie by the same name. Some of Rockwell's illustrations are on the slip case — 1975

1978 Value $10.00
Current Value $12.00

McDonald's Hamburgers
Advertising posters 1972-1973
1978 Value $3.00

Boy Scout Calendars
Boy Scouts of America
1925 to 1945 Current Value $25.00
1946 to 1956 Current Value $15.00
1957 to 1977 Current Value $10.00

STAGECOACH — The Movie Rockwell had a "bit" of an acting part in. Painted many portraits, including Bing Crosby and Ann Margret for the film's promotion in 1966. Produced by 20th Century Fox. No established value

MISCELLANEOUS

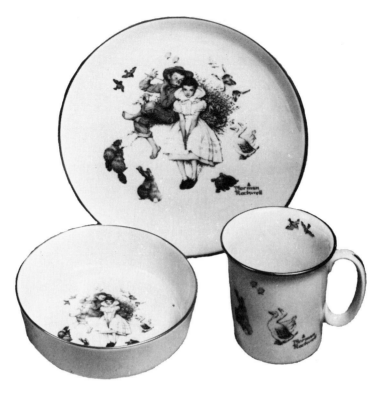

*1976 Spring Duet Children's China

Gorham Fine China

Plate 7½ inch diameter

Bowl 5¼ inch diameter

Cup 3 inch diameter

3 piece set

Issue Price $16.50

1977 Children's China

Gorham Fine China

3 piece set

Issue Price $16.50 *Art from the archives of Brown & Bigelow

MISCELLANEOUS

Window Display for Brentwood Sweaters

Circa 1941

1978 Value $24.00

Value Unchanged

War Bond Holder **Four Freedoms**

1943 Promotion

1978 Value $15.00
Current Value $18.00

Four Freedoms

Deluxe brochure promotional

From *S.E.P.* 1943

1978 Value $20.00
Current Value $30.00

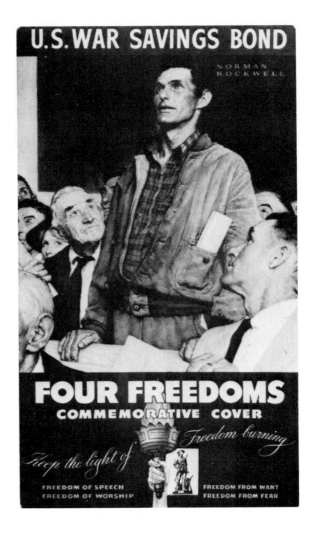

MISCELLANEOUS

Saturday Evening Post Envelope — 1971

Featuring Norman Rockwell and

Paperboy. "The Post Is Back!"

1978 Value $1.00

Current Value $2.50

The Post is back!

Tiny Tim Christmas Card — 1975

S.E.P. Give-away with gift subscriptions

1978 Value $2.00

Value Unchanged

Encyclopedia Britannica 11th Edition

Brochure contains two Rockwell illus.

1978 Value $3.00

Value Unchanged

Portfolio of Rockwell Prints

Published by *S.E.P.*

18" x 25" signed by artist

1976 Value $1,000.00

1978 Value $1,200.00

Current Value $1,500.00

National Cowboy Hall of Fame Pamphlet

Photo of Rockwell and Walter Brennan

1978 Value $3.00

Current Value $5.00

MISCELLANEOUS

The Men and Machines of Modern Steelmaking

Sharon Steel Corporation brochure — 1968

Contains a series of fourteen portraits

in a background of steel-making situations.

The portraits were painted in 1965-1966,

the brochure was published in 1968. These

illustrations are the same as those used in

Fortune and *Industry Week* magazines.

Thirty pages, with fourteen illustrations

in color, and a special inscription about

Mr. Rockwell and his very special assistant,

Molly Rockwell.

1978 Value $25.00/Current Value $30.00

Normal Rockwell Decoupege Kit

Set of four 3¼"x 4" plaques

Issue Price $4.95 and $6.95

1978 Value $5.00 and $7.00

Value Unchanged

John Denver & Friend

A.B.C. television program

using Rockwell illustrations

as portion of John Denver's

Special T.V. show March 29, 1976

No value established

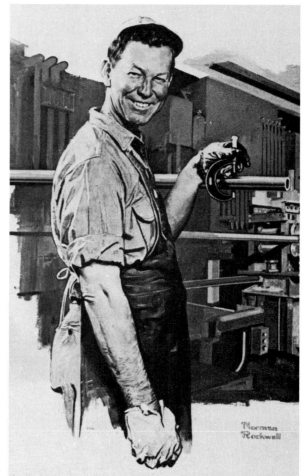

MISCELLANEOUS

Four Seasons Decorative Clock

Yeld House Catalog 1974

Framed print with clock inset

Issue Price $57.00

1978 Value $65.00

Value Unchanged

Mirrors glazed with Rockwell illustrations

No value established

Those Wonderful School Years

Memory Album

No value established

Baseball Hall of Fame Post Card

Foldout type — 1950 circa

1978 Value $6.00

Value Unchanged

Stand-up cardboard poster

Interwoven socks

Approximately 34 inches high

1978 Value $25.00

Value Unchanged

Souvenir Program 1972

Mount Eisenhower Wayside Park

Dwight D. Eisenhower on cover

1978 Value $20.00

Current Value $22.00

Bernard Danenberg Gallery Catalog

11" x 12" folder

1978 Value $10.00

Current Value $12.00

Tiny Tim Candles

Hallmark Corp.

3 inch diameter, 6 inches high

15,500 produced 1975-76

Issue Price $5.00

Current Value $8.00

Drinking glasses

Anchor Hocking

Set of four (only two with Rockwell illus.)

After the Prom S.E.P. May 25, 1957

Sun Struck S.E.P. July 13, 1940

Approximately 100,000 produced 1978

Issue price $5.95

Value Unchanged

MISCELLANEOUS

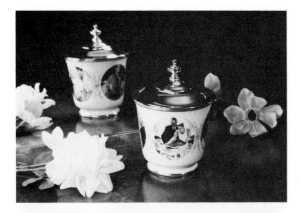

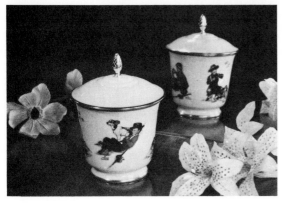

Four Freedoms Covered Cache'pot

Gorham Fine China

Height 6½" diameter 5"

Permanently available

Freedom From Want

Freedom From Fear

Freedom Of Speech

Freedom Of Worship

1979 Issue Price $75.00

Four Seasons Covered Cache'pot

Gorham Fine China, Series No. 1

Heighth 6½" diamete. 5"

Limited Edition 9,800, hand numbered

Depicts 1958 calendar year.

Illustrations title, **Boy and His Dog**

1979 Issue Price $50.00

Nature Friends Thimbles

Gorham Fine China

Set of six:

NF-1 Turtles

NF-2 Racoons

NF-3 Deer

NF-4 Foxes

NF-5 Ducks

NF-6 Rabbits

1979 Issue Price $14.50 each piece

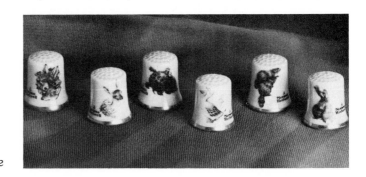

MISCELLANEOUS

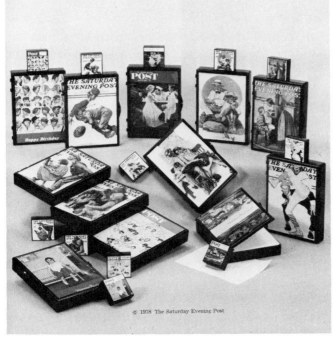

© 1978 The Saturday Evening Post

Norman Rockwell Gozinta Boxes

Schmid

No. 310-020 (S.E.P. covers) set of 12 boxes
.
1979 Issue Price $2.00 each box.

Norman Rockwell Note Boxes

Schmid

No. 310-021 (S.E.P. covers) set of 12

1979 Issue Price $7.00 each box

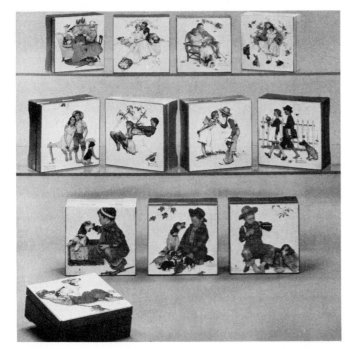

Norman Rockwell Music Boxes

Schmid (Four Seasons)

1979 Issue Price $20.00 each

MISCELLANEOUS

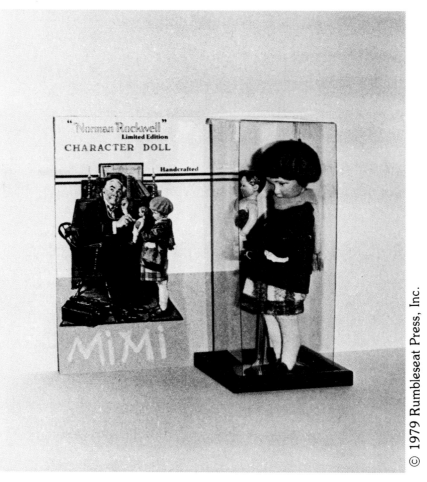

Norman Rockwell Character Dolls

Rumbleseat Press, Incorporated

Little Girl Series No. RPI/NRD-1G

10" Porcelain Bisque handcrafted in Germany

Removeable Clothes, Limited Edition

1979 Issue Price Pending

MISCELLANEOUS

The Magic Flute Paint by Number

Craft House, No. 15653, 12 x 16" oil colors

1979 Issue Price $3.25 each

Between the Acts Paint by Number

Craft House, No. 15654, 12 x 16" oil colors

1979 Issue Price $3.25 each

No Peeking Paint by Number

Craft House, No. 15652, 12 x 16" oil colors

1979 Issue Price $3.25 each

Catching the Big One Paint by Number

Craft House, No. 15651, 12 x 16" oil colors

1979 Issue Price $3.25 each

Norman Rockwell Oval Display Bases

Dave Grossman Designs, Inc.

RB-1 2¾" x 4" (small) 1979 Issue Price $5.00

RB-2 4" x 6" (medium) 1979 Issue Price $7.00

RB-3 5" x 7" (large) 1979 Issue Price $9.00

Norman Rockwell Plate Display Frames

Dave Grossman Designs, Inc.

NRF-1 Small Rockwell frame, 1979 Issue Price $12.00

NRF-3 Large Rockwell frame, 1979 Issue Price $14.00

MISCELLANEOUS

Pals NRL-1

Dave Grossman Designs, Inc.

1000 hand numbered pieces

20" x 27" full color on 100% rag paper

1978 Issue Price $100.00 (edition closed)

Current Value $150.00

Bringing Home the Tree NRL-2

Dave Grossman Designs, Inc.

1000 hand numbered pieces

20" x 27" full color on 100% rag paper

1978 Issue Price $100.00

Current Value $100.00

On the Ice NRL-3

Dave Grossman Designs, Inc.

1000 hand numbered pieces

20" x 27" full color on 100% rag paper

1979 Issue Price $100.00

Come On In NRL-4

Dave Grossman Designs, Inc.

1000 hand numbered pieces

20" x 27" full color on 100% rag paper

1979 Issue Price $100.00

Christmas Ornament Base

Dave Grossman Designs, Inc.

2¾" x 4"

1979 Issue Price $6.00

Norman Rockwell Mirrors

Certified Rarieties, Inc.

1979 Issue Price $16.00

Gee-Whiz Note Paper

Leanin' Tree Publishing Co.

4¾" x 6" notes with envelopes

1979 Issue Price $3.00 per box of eight

Gee-Whiz Greeting Cards

Leanin' Tree Publishing Co.

5½" x 7¼" cards for special occasions

1979 Issue Price 75¢ each

Gee-Whiz Christmas Cards

Leanin' Tree Publishing Company

5½" x 7¼" Christmas cards

1979 Issue Price $5.00 box of 12

Heirloom Rockwell StitchArt

Sales Aides International

9" x 12" stitchery kits

Young Love

Going Out

Big Surprise or *Uncle Gil's Surprise*

Marble Players

1979 Issue Price $12.50

Christmas Wrapping Paper

CPS Industries

A variety of illustrations taken

from The Saturday Evening Post covers

Saturday Evening Post Reproductions

Kimberly-Clark's promotional

Moonlight Buggy Ride

Going Out

Rosie the Riveter

Girl in the Mirror

1979 Issue Price - a premium gift

MUGS, STEINS

 From the ancient hand-carved beer steins of Bavaria through the Toby mugs of Elizabethan England to the Shirley Temple cups of the 30's, beverage containers have long been sought after by collectors.

 Rockwell art applied to this collector medium continues this tradition as is evident with the classic sculpture of the Gorham, "Four Seasons" steins. You can look for this area to grow into one of the more popular categories of collecting.

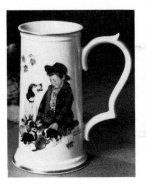 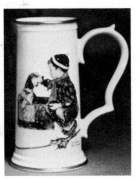 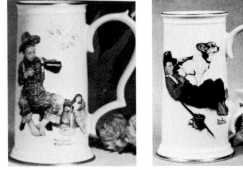

***Pride of Parenthood** Stein Series No. 1

 Gorham Fine China

 8 inches high

 Limited Edition 9,800

 1976 Issue Price $25.00

 Current Value $75.00

***The Mysterious Malady** Stein Series No. 3

 Gorham Fine China

 8 inches high

 Limited Edition 9,800

 1978 Issue Price $27.50

 Current Value $30.00

***A Boy Meets His Dog** Stein Series No. 2

 Gorham Fine China

 8 inches high

 Limited Edition 9,800

 1977 Issue Price $25.00

 Current Value $55.00

***Adventurers Between Adventures**

 Gorham Fine China, Stein No. 4

 8" limited edition, 9,800

 1979 Issue Price $38.00

**Art from the archives of Brown & Bigelow*

MUGS, STEINS

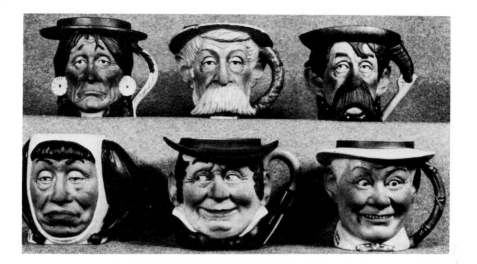

See America First Toby Mug NRM-1

Dave Grossman Designs, Inc.

S.E.P. 4/23/38

1979 Issue Price $35.00

Dreams of Long Ago Toby Mug NRM-2

Dave Grossman Designs, Inc.

S.E.P. 8/13/27

1979 Issue Price $35.00

Merrie Christmas Toby Mug NRM-3

Dave Grossman Designs, Inc.

S.E.P. 12/3/21

1979 Issue Price $35.00

Jester Toby Mug NRM-4

Dave Grossman Designs, Inc.

S.E.P. 2/11/39

1979 Issue Price $35.00

The Hobo Toby Mug NRM-5

Dave Grossman Designs,Inc.

S.E.P. 10/18/24

1979 Issue Price $35.00

Catching the Big One Toby Mug NRM-6

Dave Grossman Designs, Inc.

S.E.P. 8/3/29

1979 Issue Price $35.00

ORNAMENTS

Because of their growing popularity a new single chapter has been established for ornaments, a natural medium for Rockwell's art. Christmas . . . a time for families, children, reunions and reflections of Christmas' past — all favorite topics of the artist.

Several new ornaments were introduced during the past year, and all indications are that the growth pattern will continue. The instant success of Dave Grossman's, "The Carroler," may indicate a growing trend toward figurine-like characters as ornaments.

1976 Christmas Ornament

Hallmark Cards, Inc.

3¼" #B300 QX196-1 (not pictured)

1976 Issue Price $3.00

Current Value $6.00

1977 Christmas Ornament

Hallmark Cards, Inc.

3¼" #350 QX151-5

1977 Issue Price $3.50

Current Value $5.00

Tree Trimmer Series

Hallmark Cards, Inc.

Series Number QX134-1

1975 Issue Price $3.00

1978 Value $8.00

Faces of Christmas Series No. 1

Dave Grossman Designs, Inc.

Style NRO-1 Limited Edition

(S.E.P. 12/4/20)

1975 Issue Price $3.50

1978 Value $14.00

Value Unchanged

Santa Planning Visit No. 2

Dave Grossman Designs, Inc.

Style NRO-2 Limited Edition

(S.E.P. 12/4/26)

1976 Issue Price $4.00

1978 Value $8.00

Value Unchanged

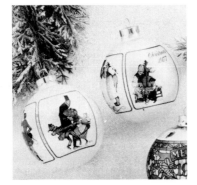
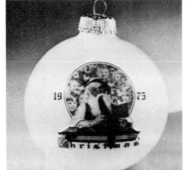

ORNAMENTS

The Carroler NRX-3

Dave Grossman Designs, Inc.

2¾", 20,000 limited edition

S.E.P. 12/8/23

1978 Issue Price $15.00

Current Value $30.00 , Edition Closed

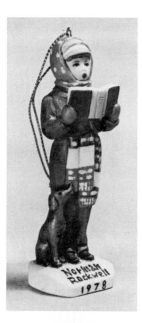

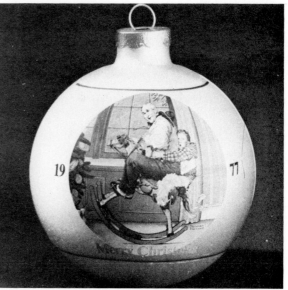

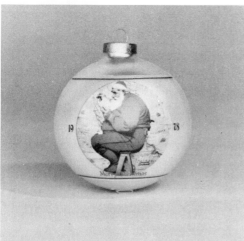

Rocking Horse NRO-3

Dave Grossman Designs, Inc.

(*S.E.P.* 12/16/33) 3¼" diameter

1977 Issue Price $4.00

Current Value $4.50

Santa's Road Map

Dave Grossman Designs, Inc.

3¼ inch diameter, *S.E.P.* 12/16/39 Cover

1978 Issue Price $4.50

Value Unchanged

ORNAMENTS

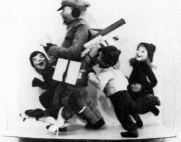

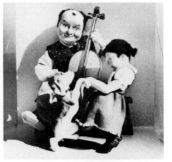

Christmas In Carmel

Reproduced from Hallmark Christmas cards

in textured sculptures. Set of 12 ornaments

1978 Bid Price $450.00

Current Value $4,000.00

Drum for Tommy NRX-24

Dave Grossman Designs, Inc.

3½" miniature, limited edition

1979 Issue Price $20.00

Snow Sculpture

Schmidt

3¾", No. 247400

1979 Issue Price $4.50

Wrapping Christmas Presents

Vesta Glass, Inc.

3¼" 1st in Heirloom Treasures Series

1979 Issue Price $6.00

Dear Santa No. 5

Dave Grossman Designs, Inc.

3¼" (S.E.P. 12-21-35)

1979 Issue price $5.00

PLATES

Plates continue to lead the list of "most popular" collectibles. At least thirty-four new plates are offered for 1979. Some of these are very good in both quality and interpretation. However, the list of plate "uncollectibles" grows longer. Serious plate collectors would do well to study the eight point reminder set forth below before making impulsive purchases.

The first edition of any collectible traditionally enjoys the greater popularity and the fastest increase in value. This has been especially true with plates. The Bradford Exchange (BRADEX), the world's largest trading center in collector plates has set forth an eight point evaluation chart to guide plate collectors in their selections.

ARTISTRY — A plate's artistic quality makes it desirable.

MAKER — Reputation for quality.

RARITY — This is only assured by a small number being produced.

COLLECTIBILITY — Will other collectors want one?

TIME OF ACQUISITION — It is always best to buy at time of issue.

MATERIAL — The base material should be the finest available.

SPONSORSHIP — The reputation of the sponsor can enhance the value.

COMMEMORATIVE IMPORTANCE — A plate should commemorate something significant.

"The Family Tree" was the first Rockwell plate produced. The quality of that first firing set a high standard for the industry. Unfortunately, a few inferior plates have made their way into the marketplace. The astute collector is selective in the quality of his purchases.

Some manufacturers have been hesitant to offer production figures because full production runs are not always achieved, as was the case with the "A President's Wife" plate.

Family Tree **1970**

Gorham Fine China

10½ inch diameter, 5,000 produced

1970 Issue Price $17.00

1978 Value $175.00

Current Value $200.00

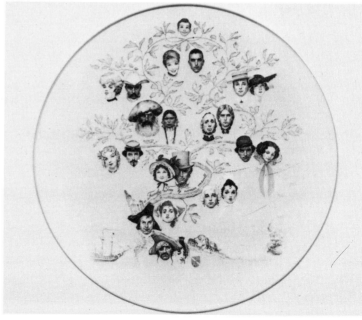

PLATES

Bringing Home the Tree

Franklin Mint Christmas No. 1

8 inch diameter, 18,321 produced

Sterling Silver

1970 Issue Price $100.00

1978 Value $225.00

Current Value $475.00

Under The Mistletoe **1971**

Franklin Mint Christmas No. 2

8 inch diameter, 24,792 produced

Sterling Silver

1971 Issue Price $100.00

1978 Value $200.00

Current Value $215.00

© 1970 Franklin Mint

PLATES

A Boy And His Dog Four Seasons

Gorham Fine China Series No. 1

10½ inch diameter, set of four

* *Adventurers Between Adventures*

* *The Mysterious Malady*

* *Pride of Parenthood*

* *A Boy Meets His Dog*

Four Seasons series limited edition

to year of issue production.

1971 Issue Price $60.00

1978 Value $375.00

Current Value $550.00

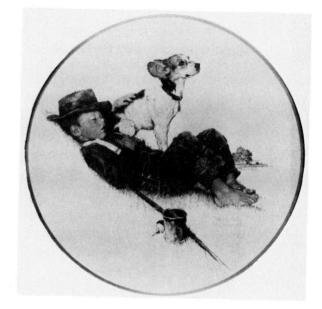

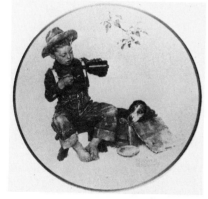

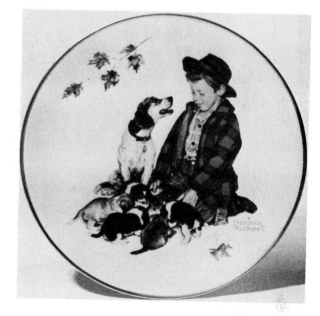

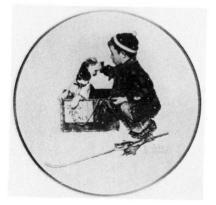

°Art from the archives of Brown & Bigelow

PLATES

Young Love *Four Seasons* **1972**

Gorham Fine China Series No. 2

10½ inch diameter, set of four

* *Beguiling Buttercup*

* *Flying High*

* *A Scholarly Pace*

* *Downhill Daring*

1972 Issue Price $60.00

1978 Value $90.00

Current Value $175.00

PLATES

Four Ages of Love *Four Seasons*

Gorham Fine China Series No. 3

10½ inch diameter, set of four

* *Sweet Song So Young*

* *Flowers In Tender Bloom*

* *Fondly Do We Remember*

* *Gaily Sharing Vintage Times*

1973 Issue Price $60.00

1978 Value $180.00

Current Value $335.00

1973

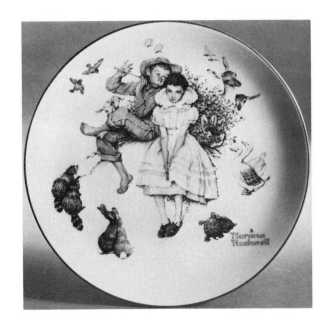

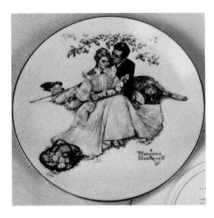

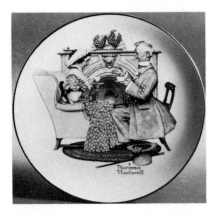

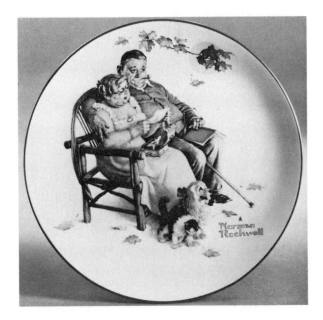

* *Art from the archives of Brown & Bigelow*

PLATES

Grandpa And Me Four Seasons

Gorham Fine China Series No. 4

10½ inch diameter, set of four

* *Day Dreamers*

* *Goin' Fishin'*

* *Pensive Pals*

* *Gay Blades*

1974 Issue Price $60.00

1978 Value $90.00

Current Value $125.00

1974

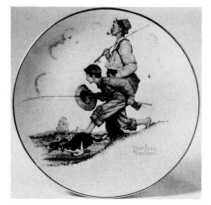

PLATES

Me And My Pal Four Seasons

Gorham Fine China Series No. 5

½ inch diameter, set of four

* *Young Man's Fancy*

* *Fisherman's Paradise*

* *Disastrous Daring*

* *A Lickin' Good Bath*

1975 Issue Price $70.00

1978 Value $70.00 high

Current Value $175.00

1975

PLATES

Grand Pals Four Seasons

Gorham Fine China Series No. 6

10½ inch diameter, set of four

* *Soaring Spirits*

* *Fish Finders*

* *Ghostly Gourds*

* *Snow Sculpturing*

1976 Issue Price $70.00

1978 Value $70.00

Current Value $170.00

* *Art from the archives of Brown & Bigelow*

1976

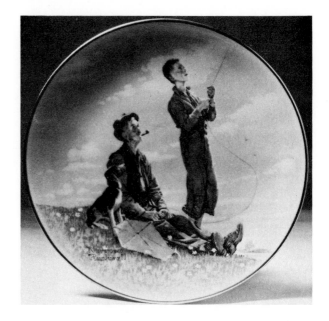

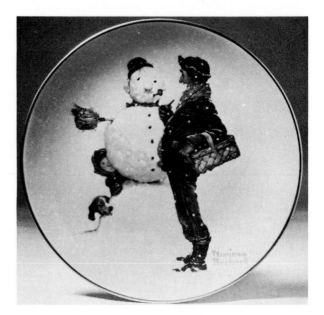

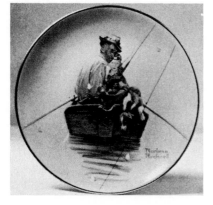

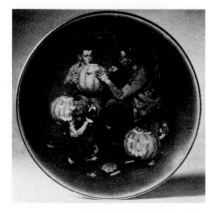

PLATES

Going On Sixteen Four Seasons

Gorham Fine China Series No. 7

10½ inch diameter, set of four

* *Sweet Serenade*

* *Shear Agony*

* *Pilgrimage*

* *Chilling Chore*

1977 Issue Price $75.00
Current Value $180.00

1977

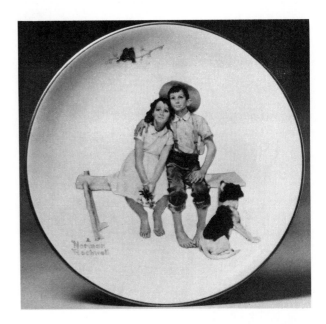

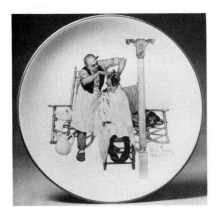

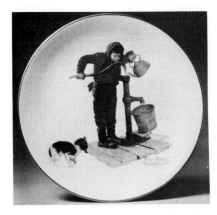

PLATES

The Tender Years Four Seasons

Gorham Fine China Series No. 8

10½ inch diameter, set of four

* *Chilly Reception*

* *Spring Tonic*

* *New Year Look*

* *Cool Aid*

1978 Issue Price $100.00

Current Value $115.00

1978

PLATES

A Helping Hand Four Seasons **1979**

Gorham Fine China, Series No. 9

Closed for Business

Swatter's Rights

The Coal Season's Coming

Year End Count

10½" diameter, set of four

1979 Issue Price $100.00

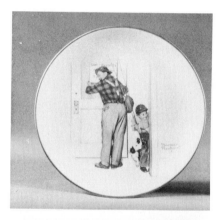

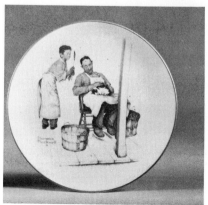

PLATES

The Carolers

Franklin Mint Christmas No. 3

8 inch diameter, 29,074 produced

Sterling Silver

1972 Issue Price $125.00

1978 Value $175.00
Current Value $190.00

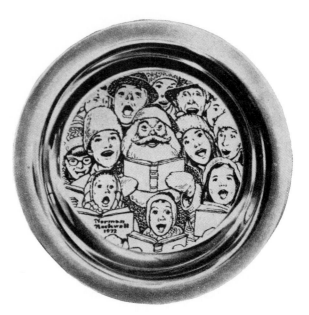

Butter Girl

Lake Shore Prints No. 1

8½ inch diameter, 9,433 produced

1973 Issue Price $14.95

1978 Value $160.00
Current Value $200.00

Trimming The Tree

Franklin Mint Christmas No. 4

8½ inch diameter, 18,010 produced

Sterling silver in deluxe library case

1973 Issue Price $125.00

1978 Value $175.00
Current Value $210.00

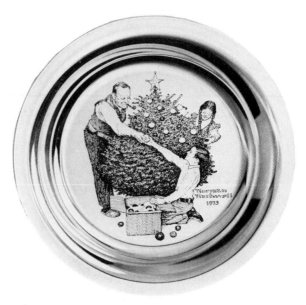

The Streakers

Gorham Fine China

8½ inch diameter

1974 Issue Price $14.50

1978 Value $30.00 Value Unchanged

PLATES

Hanging the Wreath

Franklin Mint Christmas No. 5

8 inch diameter, 12,822 produced

Sterling silver in deluxe library case

1974 Issue Price $175.00

1978 Value $175.00 high — $95.00 low
Current Value $225.00

© Franklin Mint

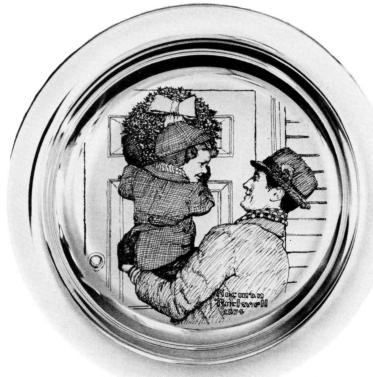

PLATES

Weighing In

Gorham Fine China

8½ inch diameter

1974 Issue Price $12.50

1978 Value $25.00

Value Unchanged

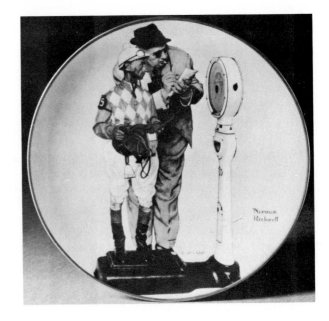

Scotty Gets His Tree

Rockwell Society Christmas No. 1

8¼ inch diameter

1974 Issue Price $24.00

1978 Value $90.00 Current Value $125.00

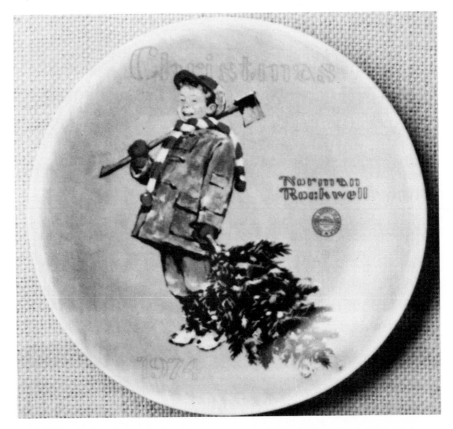

PLATES

Tiny Tim

Gorham Fine China Christmas No. 1

8½ inch diameter

1974 Issue Price $12.50

1978 Value $36.00
Current Value $30.00

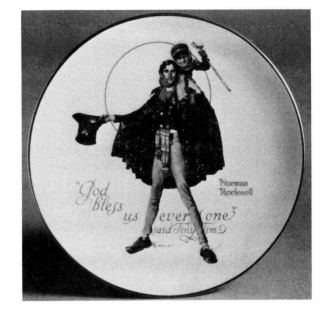

Truth About Santa

Lake Shore Prints Christmas No. 2

8½ inch diameter, 15,141 produced

1974 Issue Price $19.50

1978 Value $30.00
Current Value $32.00

Tom Sawyer Series

Ridgewood Industries, Inc.

8½ inch diameter, 3,000 produced

Set of four in sepia

Painting the Fence

Taking the Medicine

Lost In the Cave

Trying A Pipe

1974 Issue Price $39.95 per set

1978 Value $140.00
Current Value $150.00

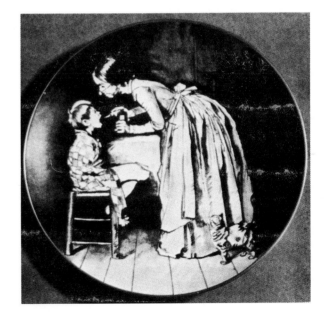

PLATES

Joy Unconfined or **Downhill Daring**

Royal Devon Christmas No. 1

8½ inch diameter

1975 Issue Price $24.50

1978 Value $60.00
Current Value $50.00

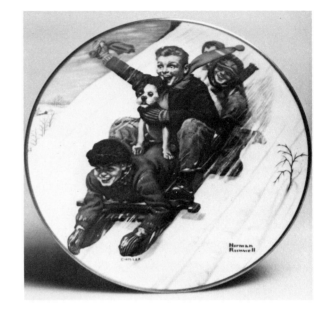

Santa's Helpers

The Lincoln Mint Christmas Plate

9'' diameter, sterling silver

1975 Issue Price $175.00

1978 Value $150.00
Current Value $160.00

Santa's Helpers

The Lincoln Mint Christmas Plate

9 inch diameter in pewter

1975 Issue Price $45.00

1978 Value $40.00

Current Value $50.00

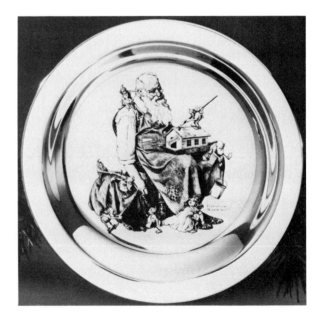

PLATES

Good Deeds

Gorham Fine China Christmas No. 2

8½ inch diameter

1975 Issue Price $17.50

1978 Value $36.00
Current Value $30.00

Ben Franklin

Gorham Fine China

8½ inch diameter, 18,500 produced

1975 Issue Price $19.50

1978 Value $24.00 Value Unchanged

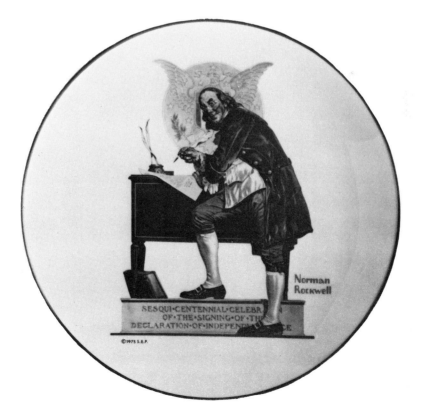

PLATES

Doctor And Doll

Royal Devon No. 1 Mother's Day

8½ inch diameter

1975 Issue Price $23.50

1978 Value $75.00
Current Value $80.00

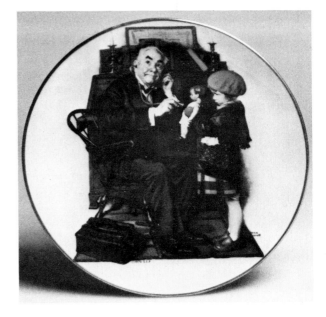

A President's Wife

Lake Shore Prints No. 4

Less than 1000 reported in edition

10½ inch diameter in satin lined case

1975 Issue Price $70.00

Current Value $80.00

Home For Christmas

Franklin Mint Christmas No. 6

8 inch diameter, 11,059 produced

Sterling silver in deluxe library case

1975 Issue Price $180.00

1978 Value $180.00

Current Value $200.00

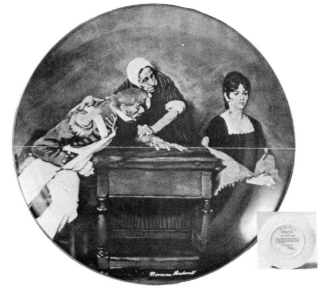

PLATES

Golden Rule

Gorham Fine China

8½ inch diameter

1975 Issue Price $12.00

1978 Value $15.00

Current Value $30.00

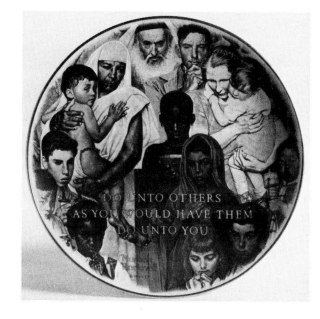

Home From the Fields

Lake Shore Prints No. 3

8½ inch diameter, 8,500 produced

Taken from rare watercolor

1975 Issue Price $24.50

1978 Value $35.00

Current Value $25.00

Angel With A Black Eye

Rockwell Society of America Christmas No. 2

8¼ inch diameter

1975 Issue Price $24.00

1978 Value $63.00

Current Value $60.00

PLATES

Our Heritage

Boy Scouts of America Series No. 1

8½ inch diameter, 18,500 produced

1975 Issue Price $19.50

1978 Value $20.00

Current Value $27.50

A Good Sign for Everyone

Boy Scouts of America No. 3

8½ inch diameter, 18,500 produced

1976 Issue Price $19.50

1978 Value $20.00

Current Value $22.50

A Scout Is Loyal

Boy Scouts of America No. 2

8½ inch diameter, 18,500 produced

1976 Issue Price $19.50

1978 Value $20.00

Current Value $25.00

The Scoutmaster

Boy Scouts of America Series No. 4

8½ inch diameter, 18,500 produced

1976 Issue Price $19.50

1978 Value $20.00

Current Value $20.00

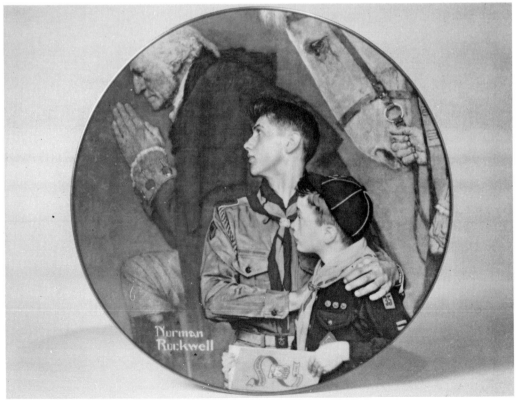

Abe Lincoln

Sculpted by Roger Brown

River Shore, Ltd. Famous Americans Series No. 1

Solid Copper in-relief, 9,500 produced

8 inch diameter, 16 ounces

1976 Issue Price $40.00

1978 Value $400.00

Current Value $ 420.00

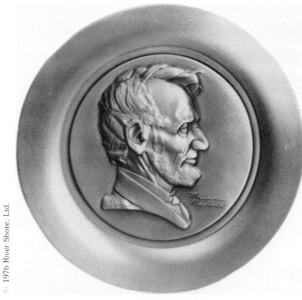

© 1976 River Shore, Ltd.

Painting The Fence

Tom Sawyer Series No. 1

Dave Grossman Designs, Inc.

8½ inch diameter, 10,000 produced

1976 Issue Price $18.50

Current Value $95.00

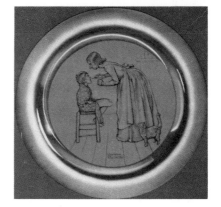

Tom Sawyer Taking His Medicine

Continental Mint, Inc.

7¾ inch diameter

24 Kt. gold plated on pewter

1976 Issue Price $35.00

Current Value $40.00

PLATES

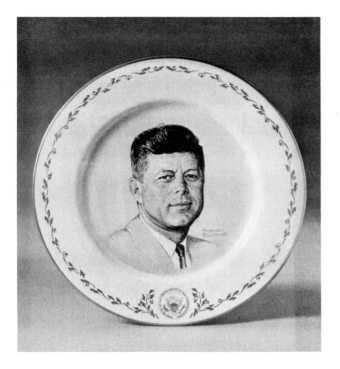

John F. Kennedy

Gorham Fine China

10½ inch diameter, 9,800 produced

1976 Issue Price $30.00
Current Value $40.00

The Christmas Homecoming

The Hamilton Mint

Antique Pewter

1976 Issue Price $40.00
Current Value $50.00

PLATES

Golden Christmas

Rockwell Society of America Christmas No. 3

8¼ inch diameter

1976 Issue Price $24.50

1978 Value $27.00

Current Value $30.00

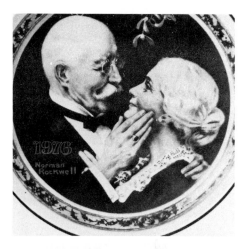

Sweethearts

Living American Artists Series No. 1

Commemorative Imports by Sango

10½ inch diameter

1976 Issue Price $30.00

Current Value $30.00

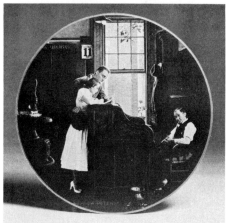

The Marriage License

Gorham Fine China, *S.E.P.* 6/11/55

10½ inch diameter,

1976 Issue Price $25.00

1978 Value $32.00

Current Value $35.00

Dwight D. Eisenhower

Gorham Fine China

10½ inch diameter, 9,800 produced

1976 Issue Price $30.00

Current Value $40.00

PLATES

Christmas Trio

Gorham Fine China Christmas No. 3

8½ inch diameter

1976 Issue Price $19.50

1978 Value $19.50
Current Value $25.00

Puppy Love

Royal Devon Mother's Day No. 2

8½ inch diameter

1976 Issue Price $24.50

1978 Value $30.00
Current Value $35.00

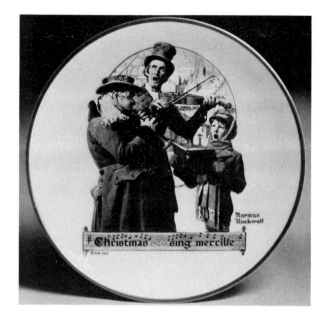

Santa's Arrival

Continental Mint, Inc.

8 inch diameter

Gold on pewter in presentation case

1976 Issue Price $50.00

Current Value $50.00

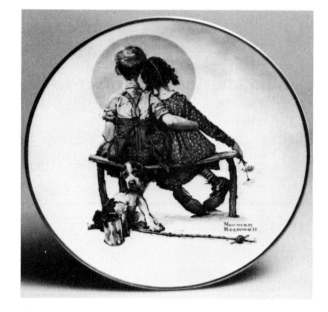

PLATES

A Mother's Love Mother's Day Series No. 1

The Rockwell Society of America

8¼ inch diameter

1976 Issue Price $24.50

1978 Value $48.00

Current Value $65.00

Christmas Gift or **Rocking Horse**

Royal Devon Christmas No. 2

8½ inch diameter

1976 Issue Price $24.50

1978 Value $24.50

Current Value $36.00

Four Freedoms

American Express Bicentennial

Gorham Fine China

1½ inch diameter, set of four

Freedom of Speech

Freedom of Worship

Freedom From Want

Freedom From Fear

1976 Issue Price $45.00 per plate

Current Value $50.00

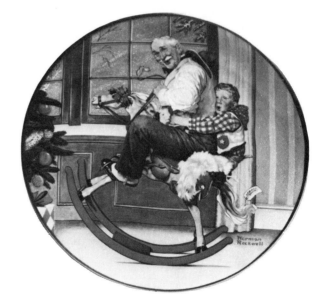

PLATES

American Sweethearts

The Franklin Mint

Crystal Plate Collection

8½ inch diameter, etched crystal

Set of Six:

Youngsters at Play - AMS-1

Teenagers Together - AMS-2

Bride and Groom - AMS-3

Proud Parents - AMS-4

Graduation Day - AMS-5

Sweethearts Forever - AMS-6

Limited Edition 1,004 produced

1977-1978 Issue Price $120.00 per plate

Current Value $160.00

© Franklin Mint

Yuletide Reckoning

Gorham Fine China

8½ inch diameter

1977 Issue Price $19.50

Current Value $20.00

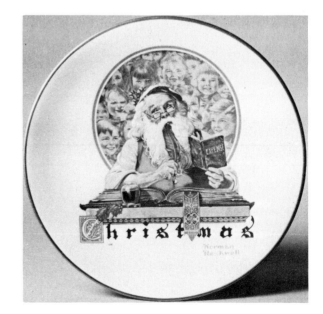

PLATES

The American Family Series

by Norman Rockwell Museum

8 inch diameter, 9,900 produced

Series of 12:

Baby's First Step

Happy Birthday, Dear Mother

Sweet Sixteen

First Haircut

First Prom

The Student

Wrapping Christmas Presents

Birthday Party

Little Mother

Washing Our Dog

Mother's Little Helpers

Bride & Groom

1977 Issue Price $28.50 each plate

Current Value $28.50

PLATES

Faith Mother's Day No. 2

Rockwell Society of America

8¼ inch diameter

1977 Issue Price $24.50

1978 Value $24.50
Current Value $35.00

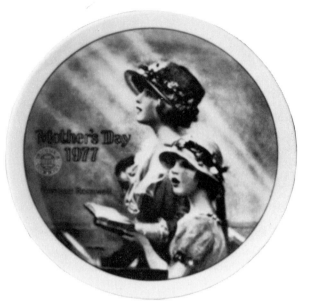

The Toy Maker Heritage Series No. 1

Rockwell Society of America

8¼ inch diameter

1977 Issue Price $14.50

Current Value $90.00

Looking Out to Sea (Miniature)

The Best of Rockwell Series No. 1

Creative World

1 inch x 1 inch deep relief copper

15,000 produced & numbered

1977 Issue Price $9.95

PLATES

The Runaway

Gorham Fine China & Brown & Bigelow

10½ inch diameter, 7,500 produced

1977 Issue Price $45.00

Current Value $55.00

An Old Fashioned Thanksgiving

The Franklin Mint

8" dia., sterling silver

1977 Issue Price $185.00

Current Value $250.00

© The Franklin Mint

PLATES

The Toy Shop Window

Rockwell Society of America Christmas No. 4

8¼ inch diameter

1977 Issue Price $24.50

1978 Value $24.50
Current Value $38.00

The Big Moment

Royal Devon Christmas No. 3

8½ inch diameter

1977 Issue Price $27.50
Current Value $30.00

First Smoke

Tom Sawyer's Series No. 2

Dave Grossman Designs, Inc.

10,000 , Limited Edition

1977 Issue Price $24.00

1978 Value $25.00 Current Value $50.00 Edition Closed

PLATES

Rockwell's Rockwell

Sculpted by Roger Brown

River Shore, Ltd. Famous Americans Series No. 2

Solid copper in-relief, 9,500 produced

8 inch diameter, 16 ounces

1977 Issue Price $45.00

1978 Value $125.00

Current Value $150.00

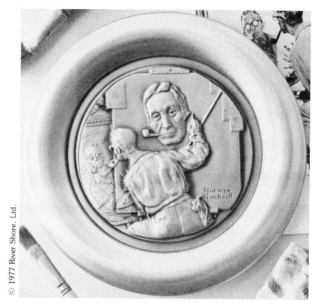

© 1977 River Shore, Ltd.

Looking Out to Sea

Sculpted by Roger Brown

Creative World Series No. 1

8 inch diameter, solid copper

1977 Issue Price $50.00

Current Value $75.00

Doctor And The Doll

Norman Rockwell Collectors Club

Creative Arts, Ltd.

Free with membership in club

1977 Issue Price $12.50

Value Unchanged

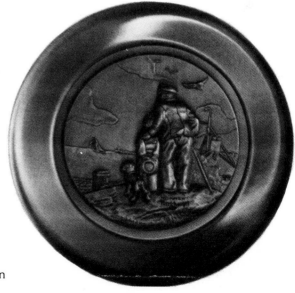

Take Your Medicine

Tom Sawyer Series No. 3

Dave Grossman Designs, Inc.

8½ inch diameter, 10,000, Limited Edition

1977 Issue Price $24.00 Edition Closed

Current Value $32.50

PLATES

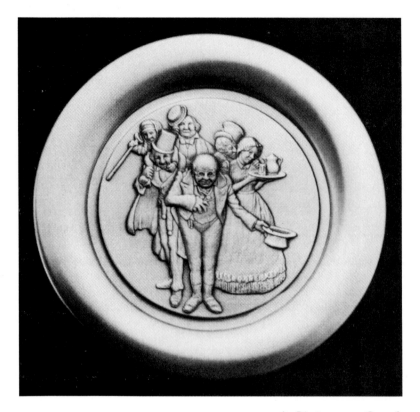

A Christmas Carol

The Danbury Mint

Private, unpublished sketch

8" diameter, limited edition

1977 Issue Price $25.00

PLATES

Spirit of Lindbergh

River Shore, Ltd., 4th famous American

8" pure copper bas relief, limited to 9,500

1978 Issue Price $50.00 Value Unchanged

© 1978 River Shore. Ltd.

The Family

Royal Devon Mother's Day Series No. 3

8½ inch diameter

1977 Issue Price $24.50 Current Value $45.00

PLATES

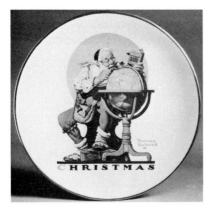

Planning Christmas Visit

Gorham Fine China

8½ inch diameter

1978 Issue Price $24.50
Current Value $35.00

Lost In Cave

Tom Sawyer Series No. 4

Dave Grossman Designs, Inc.

8½ inch diameter, 10,000 Limited Edition

1978 Issue Price $25.00
Current Value $50.00

Mother's Day Off

Royal Devon Mother's Day No. 4

8½ inch diameter

1978 Issue Price $27.50
Current Value $45.00

Yankee Doodle

The Best of Rockwell Series No. 2

Creative World

8" diameter, 15,000 numbered

Deep relief copper

1978 Issue Price $50.00
Value Unchanged

Yankee Doodle (Miniature)

The Best of Rockwell Series No. 2

Creative World

One inch to one inch deep relief copper

15,000 produced and numbered

1978 Issue Price $9.95

Value Unchanged

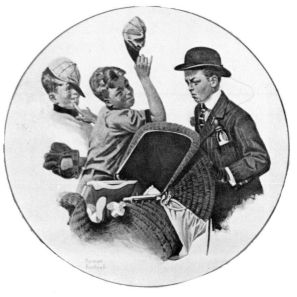

PLATES

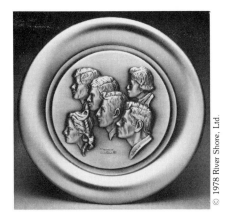

© 1978 River Shore, Ltd.

Peace Corps

Sculpted by Roger Brown

River Shore, Ltd. Famous American Series No. 3

Solid copper in-relief, 9,500 produced

8 inch diameter, 16 ounces

1978 Issue Price $45.00

Current Value $85.00

Bedtime Mother's Day Series No. 3

Rockwell Society of America

8¼ inch diameter

1978 Issue Price $24.50

Current Value $60.00

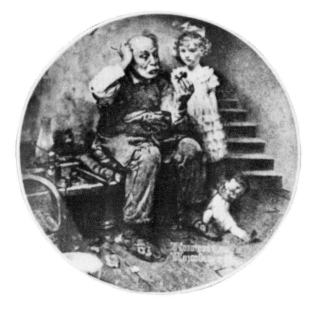

The Cobbler Heritage Series No. 2

Rockwell Society of America

8¼ inch diameter

1978 Issue Price $19.50

Current Value $55.00

PLATES

The Norman Rockwell Collection

The Danbury Mint

8½" limited edition, set of 12

Ship Ahoy (8-19-22)

Back to School (9-14-35)

Pals (9-27-24)

Grandpa's Girl (2-3-23)

Saturday's Heroes (11-21-25)

Tea for Two (10-22-27)

Plumbers (6-21-51)

Dear Diary (3-21-42)

Circus Clown (5-18-18)

Man Threading a Needle (3-8-22)

End of Christmas (1-8-27)

Catching the Big One (8-3-39)

1978 Issue Price $23.50 each

The Saturday Evening Post covers

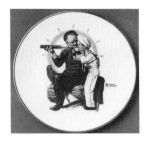

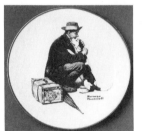
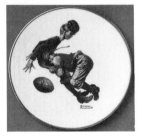

Yankee Doodle

Creative World, Ltd.

8" pure copper, limited to 15,000

1978 Issue Price $50.00

Christmas Dream

Rockwell Society of America

8¼", 5th in Christmas series

1978 Issue Price $24.50

(not pictured)

April Fool

Certified Rarities

Limited Edition, 7,500

1978 Issue Price $35.00

PLATES

Puppets for Christmas

Royal Devon, Christmas Series No. 4

8½" diameter

1978 Issue Price $27.50

The Christmas Gift

Metal Arts

8" solid copper in-relief

1978 Issue Price $48.00

The Hobo

The Hamilton Collection

8" solid copper in-relief

Limited to 9,500

1978 Issue Price $40.00

Tom Sawyer Lost In the Cave

The Continental Mint

Pure Copper, gold plated

1978 Issue Price $60.00

The Doctor

The Hamilton Collection

8" solid copper in-relief

Limited to 9,500

1978 Issue Price $40.00

A Christmas Story

Norman Rockwell Collector's Club

8½ inch diameter, limited edition

1978 Issue Price $24.50

Doctor and the Doll

Norman Rockwell Collector's Club

8½ inch diameter

1978 Issue Price $19.50

PLATES

Mother's Evening Out

Royal Devon, Mother's Day No. 5

8½" diameter

1979 Issue Price $30.00

Reflections

Rockwell Society of America

8¼" 4th in Mother's Day Series

1979 Issue Price $24.50

Lighthouse Keeper's Daughter

Rockwell Society of America

8¼" 3rd in Heritage Series

1979 Issue Price $24.50

Making Friends

The Hamilton Collection

Solid copper in-relief

8" dia., limited to 9,500

1979 Issue price $40.00

PLATES

April Fool Plate

Certified Rarities, Inc.

7,500 limited edition

1979 Issue Price $35.00

Norman Rockwell Remembered

The Norman Rockwell Museum

10 3/16 inch diameter, limited edition

1979 Issue price $45.00

Somebody's Up There

Rockwell Society of America

8¼" 6th in Christmas Series

1979 Issue Price $24.50

(not pictured)

Triple Self-Portrait

Gorham Fine China

10½" Norman Rockwell Memorial Plate

1979 Issue Price $37.50

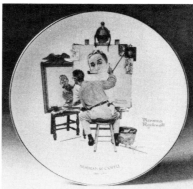

Spring Flowers

River Shore, Ltd.

10½" limited to 17,000

1979 Issue Price $75.00

Santa's Helpers

Gorham Fine China

8½" limited edition

1979 Issue Price $24.50

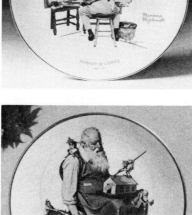

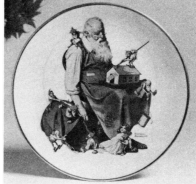

PLATES

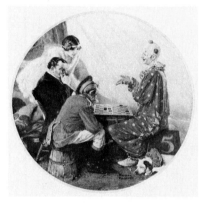

Almost Grown Up

Zelda's of Apple Valley

8" Durand French crystal

1979 Issue Price $9.99

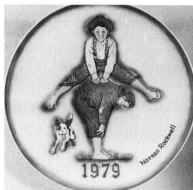

Leapfrog NRP-79

Dave Grossman Designs, Inc.

7½" diamter, bas relief

1979 Issue Price $50.00

It's Your Move

Brown & Bigelow, Clown Series No. 2

10½" limited to 7,500

1979 Issue Price $45.00

Adventurers Between Adventures

Brown & Bigelow, Bronze Series No. 1

8" limited to 9,500

1979 Issue Price $55.00

Butter Girl

Continental Mint

8" limited to 10,000

Pure copper, gold plated

1979 Issue Price $45.00

Current Value $90.00

Homecoming

Brantwood Collection, 1st Mother's Day

8½" limited to 20,000

1979 Issue Price $39.50

Tom Sawyer Smoking the Pipe

The Continental Mint

8" pure copper, gold plated

1979 Issue Price $60.00

PUZZLES

Parker Brothers has no new puzzles to issue this year, but Jaymar Industries continues to add to their line with several new challenges for 1979. Each puzzle is a reproduction of a Saturday Evening Post cover.

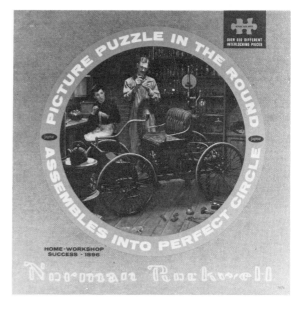

Ford 1966-1970

Jaymar Puzzles

#3076 — 19 inch round

Set of four puzzles

1978 Value $12.00 each puzzle
Current Value $20.00

Off To College 1970 - 1971 - 1972

Parker Brothers

No. 521 11" x 14"

1978 Value $8.00 to $12.00
Current Value $20.00

Runaway 1970-1971-1972-1976

Parker Brothers

No. 522 11" x 14"

1978 Value $8.00

Current Value $15.00

PUZZLES

Tomboy 1973-1974-1975

Parker Brothers

No. 535 11" x 14"

1978 Value $8.00
Current Value $12.00

Lunch Break 1973-1974-1975

Parker Brothers

No. 536 11" x 14"

1978 Value $8.00
Current Value $12.00

Ford 1953-1961

Jaymar Puzzles

#5020 — 14 inch x 19 inches

Set of Four Puzzles

1978 Value $20.00 Each Puzzle
Value Unchanged

Saying Grace 1971-1972

Parker Brothers

No. 526 11" x 14"

1978 Value $8.00 to $15.00
Current Value $12.00

Camp-Out-Of-Doors 1975-1976

Parker Brothers

No. 541 11" x 14"

1978 Value $6.95 Current Value $10.00

The Treasure Chest 1927

Louis Dow Company

1978 Value $25.00
Current Value $50.00

Homecoming 1971-1972-1973-1974

Parker Brothers

No. 525 11" x 14"

1978 Value $8.00
Current Value $10.00

Four Freedoms

Jaymar Specialty Co., Inc.

23½" x 18½", Series No. 3000

Freedom Of Speech

Freedom Of Religion

Freedom From Want

Freedom From Fear

1976 Issue Price $4.00

1978 Value $8.00

Current Value $12.00 each

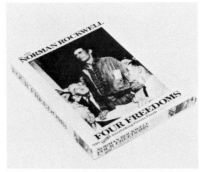

PUZZLES

Movie Stars 1974-1975-1976

Parker Brothers

No. 538 11" x 14"

1978 Value $9.00
Current Value $10.00

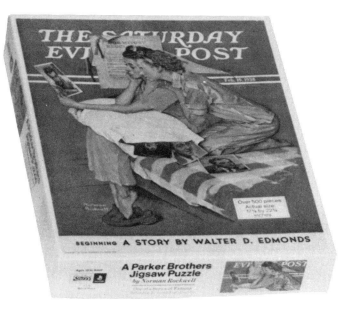

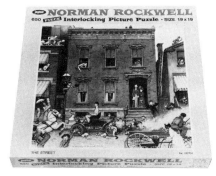

Ford 1971-1976

Jaymar Puzzles

Set of four

#66764 — 19" x 19"

1978 Value $8.00 each puzzle

Current Value $10.00

Day Coach 1975-1976

Parker Brothers

No. 542 11" x 14"

1978 Value $6.95
Current Value $8.00

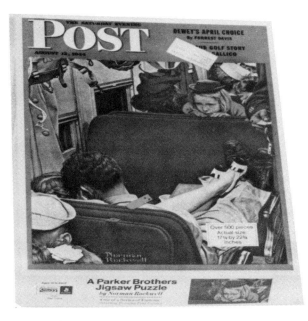

PUZZLES

The Golden Rule 1971-1972

Parker Brothers

No. 527 11" x 14"

1978 Value $8.00 to $10.00
Value Unchanged

First Prom 1972-1973

Parker Brothers

#531 11" x 14"

1978 Value $8.00

Value Unchanged

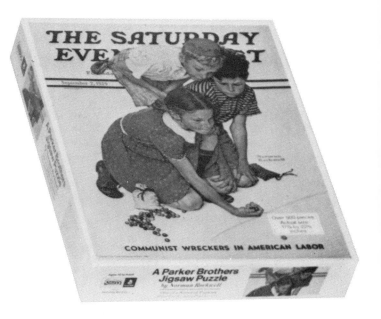

Traveling Salesman 1972-1973-1974

Parker Brothers

No. 532 11" x 14"

1978 Value $12.00

Value Unchanged

Shooting Marbles 1974-1975-1976

Parker Brothers

No. 537 11" x 14"

1978 Value $8.00 Value Unchanged

Happy Birthday Miss Jones 1973

Parker Brothers

No. 533 11" x 14"

1978 Value $10.00

Value Unchanged

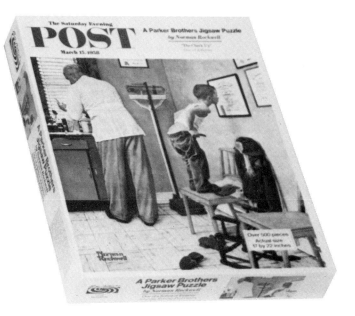

Check Up 1970-1971-1972-1973-1976

Parker Brothers

No. 523 11" x 14"

1978 Value $8.00 Value Unchanged

PUZZLES

Norman Rockwell

Jaymar Specialty Co., Inc.

18" x 13", Series No. 242

Train Station (S.E.P. 11-16-46)

Piano Tuner (S.E.P. 1-11-47)

Circus Painter (S.E.P. 5-3-47)

Restaurant Scene (S.E.P.,11-24-51)

Cheerleaders (S.E.P. 2-16-52)

Walk to Church (S.E.P. 4-4-53)

Painter at Gallery (S.E.P. 4-16-55)

Optometrist (S.E.P. 5-19-56)

1978 Issue Price $1.50 each

Salute to Norman Rockwell

Jaymar Specialty Co., Inc.

18" x 13", Series #248

Changing Tire (S.E.P. 8-3-46)

Soda Fountain (S.E.P. 8-22-53)

Girl In Mirror (S.E.P. 3-6-54)

Marriage License (S.E.P. 6-11-55)

Happy Birthday Teacher (S.E.P. 3-17-56)

Restaurant (S.E.P. 5-25-57)

Jockey (S.E.P. 6-28-58)

Window Washer (S.E.P. 9-17-60)

1979 Issue Price $2.00

COMMEMORATIVE STAMPS AND FIRST DAY COVERS

Of interest to the collector is the "Triple Self-Portrait" commemorative cover offered by the Postal Commemorative Society in memory of Mr. Rockwell. Also of interest are The Franklin Mint and Postmasters of America, commemorative cachets issued in Lake Placid and Princeton, New Jersey, respectively.

Look for the United States Postal Service to issue a commemorative stamp honoring Mr. Norman Rockwell soon.

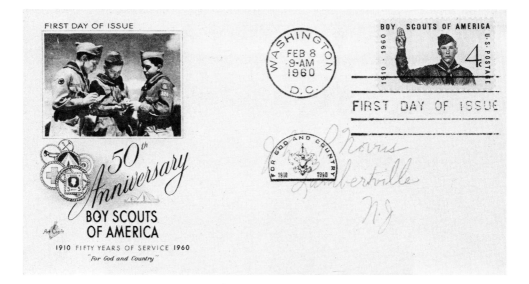

February 8, 1960

Four Cent Stamp and First Day Cover

Honoring 50th Anniversary

Boy Scouts of America

Designed by Norman Rockwell,

V.S. McCloskey Jr.;

E. Metzl and Wm K. Schrange

1,419,955 Covers Cancelled

Scott No. 1145

COMMEMORATIVE STAMPS AND FIRST DAY COVERS

October 26, 1963 Five Cent Stamp and First Day Cover
Honoring 100th Anniversary City Mail Delivery Scott No. 1238

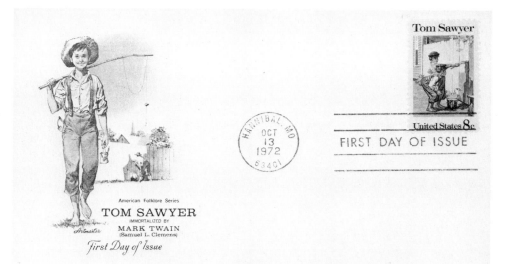

October 13, 1972

Tom Sawyer Commemorative

Eight Cent Stamp

American Folklore Series

First Day City: Hannibal, Missouri

Initial Printing 135 Million

Size: .84 x 1.44 inches

Fifty stamps to pane

Scott No. 1470

COMMEMORATIVE STAMPS
AND FIRST DAY COVERS

November 16, 1973 **Brotherhood and Human Rights** - Issue from the United Nations
8½ inches x 11 inches – Back Cover: World Federation of United Nations Association
Cachet Print with Eight Cent Stamp and Twenty-One Cent Stamp
Numbered and Limited to 2,500 Scott No. 242-243

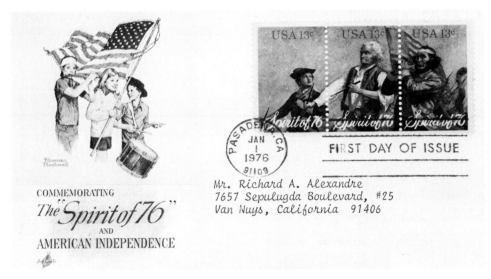

January 1, 1976 , **The Spirit of '76** , (Drummer, Flag and Fife)
Commemorative Cachet First Issue , Postmasters of America , Pasadena, California .
Original Issue Price $2.75 Scott No. 1629-1630-1631 41,472 covers issued

COMMEMORATIVE STAMPS

1978 NORMAN ROCKWELL COVER COLLECTION

Postal Commemorative Society

Series of Eight Covers Postmarked 2-3-78

Commemorating Norman Rockwell's 84th Birthday

1. *Self-Portrait* (**Triple Self-Portrait**)

2. *Puppy Love* (**The Little Spooners**) (**Young Spooners**)

3. *Friends in Need* (**Raleigh the Dog**) (**Raleigh Rockwell Travels**)

4. *The Meeting* (**First Day of School**)

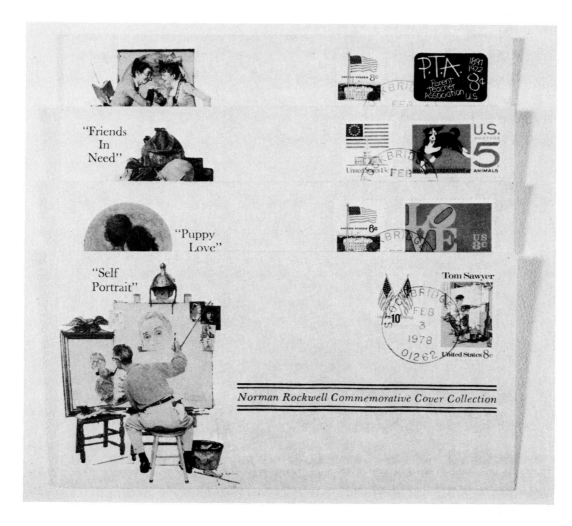

COMMEMORATIVE STAMPS

5. *Batter Up* (**100th Year of Baseball**) (**Baseball**)

6. *Doctor and Doll*

7. *Weighing In* (**The Jockey**) (**Jockey Weighing In**)

8. *Going To Church* (**Sunday Morning**) (**Off to Church**)

1978 Issue Price $19.50 Set of Eight

Current Value $30.00

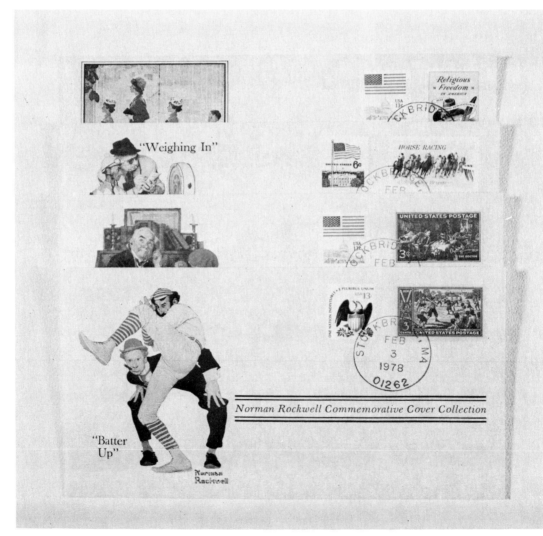

STAMPS, FIRST DAY COVERS

Norman Rockwell Classic and Historic American Stamps

Postal Commemorative Society

7½" x 4" limited edition, series of 100

The Flutist'

Passing Colors

The Wonders of Flight

The Alarm

The Young Artist

The World Remembers

Circus Strongman

The Runaway

Trick or Treat

In Training

Saturday's Heroes

Signs of Spring

Between Trains

Green Thumb

Red Cross Volunteer

Missing Tooth

Memories

The Prescription

Busybody

1978 Issue Price $3.50 each

Summer Olympic Games

The Franklin Mint for Postmasters of America

7½" x 3 7/8", 41,472 covers issued at Lake Placid, July 16, 1976

1976 Issue Price $2.75

George Washington's Victory at Princeton

The Franklin Mint for Postmasters of America

7½" x 3 7/8", 43,616 covers issued at Princeton, January 3, 1977

1977 Issue Price $2.75

STAMPS, FIRST DAY COVERS

Triple Self-Portrait

Postal Commemorative Society

3¾" x 10¾", dated Stockbridge, 2/3/79

1979 Issue Price $11.50

TRAYS

In 1930, twelve year old Dan Grant, with his flaming red hair and toothy grin, was selected from Central Casting in Hollywood to pose as Tom Sawyer for the Coca-Cola advertisements which appeared on calendars, note paper and metal serving trays .

"Who's Having More Fun?" was the title of the Jolly Green Giant (Niblets Corn) Rockwell illustration used on a tray sometime after 1939. Not many of these have survived the weight of steaming platters of delicious corn on the cob.

Collecting trays is another good starting point for the beginning collector; and, if present trends are any indication, tray collecting could grow as rapidly as plate or bell collecting. When you purchase a tray it would be wise to follow the same guidelines set forth for plates. This helps to establish and maintain a quality standard.

Coca-Cola (Tom Sawyer eating)

Coca-Cola Company promotion 1930

10½" x 13"

1978 Value $150.00

Current Value $250.00

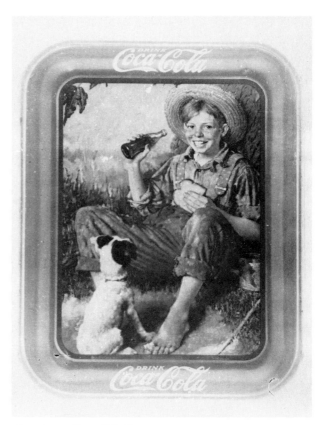

© Archives, Coca-Cola Co.

TRAYS

Who's Having More Fun? circa 1940

Green Giant Niblets Corn

17½" x 12¾"

1978 Value $38.00
Current Value $50.00

TRAYS

Checker Game APRIL FOOL 1975

Heirloom Products, Inc.

12" x 14" (over 185) mistakes

Issue Price $10.00

Current Value $15.00

Ben Franklin 1975

Dave Grossman Designs, Inc.

5000 produced

Issue Price $10.00

Current Value $12.50

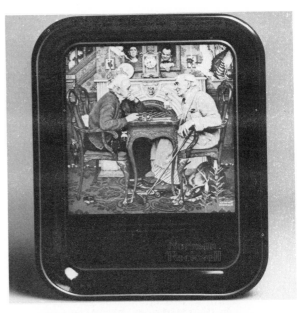

Doctor and Doll 1976

River Shore Productions, Inc.

13½ x 10½

Issue Price $12.50

Current Value $15.00

April Fool-Fishing 1977

Heirloom Products, Inc.

11" x 13" 20,000 produced

Issue Price $15.00

Current Value $15.00

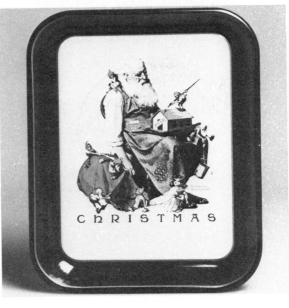

Santa's Helpers 1975

Dave Grossman Designs, Inc.

12" x 14"

Issue Price $10.00

TRAYS

The Doll Shop APRIL FOOL 1976

River Shore Productions, Inc.

11" x 13" 10,000 Ltd. Ed.

Issue Price $12.50
Current Value $12.50

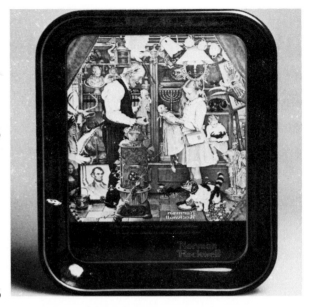

Santa Planning Annual Visit 1976

Dave Grossman Designs, Inc.

11"x 13"

Issue Price $10.00
Current Value $12.50

Santa Planning Annual Visit 1976

Lasser's Beverages

11" x 13"

Issue Price $25.00
Current Value $12.50

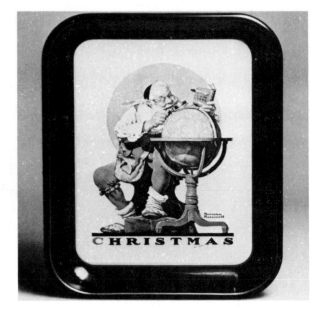

Tattoo Artist 1944 1977

Fairchild Industries

14" x 16" — 10,000 in series

Issue Price $17.50
Current Value $12.50

TRAYS

Butter Girl 1975

Heirloom Products, Inc.

13½" x 11¾"

10,000 produced

Issue Price $12.50
Current Value $15.00

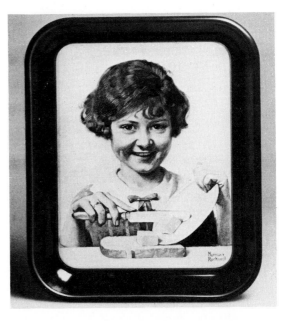

Two Boys With Hound Dogs 1976

River Shore Productions, Inc.

Limited 5,000, numbered

13½" x 10½"

Issue Price $12.50

Current Value $12.50

Triple Self-Portrait 1976

River Shore Productions, Inc.

13½" x 10½"

Issue Price $12.50

Current Value $15.00

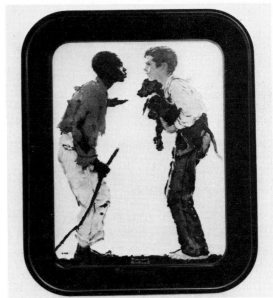

(c) 1979 River Shore, Ltd.

Looking Out to Sea 1976

River Shore Productions, Inc.

13½" x 10½"

Issue Price $12.50

Current Value $15.00

Country Postman Tray

U.S. Postal Credit Union Members

Circular, limited edition

1976 Issue Price $6.00

INDEX

INDEX

INDEX